IMAGES
of America

AMHERST

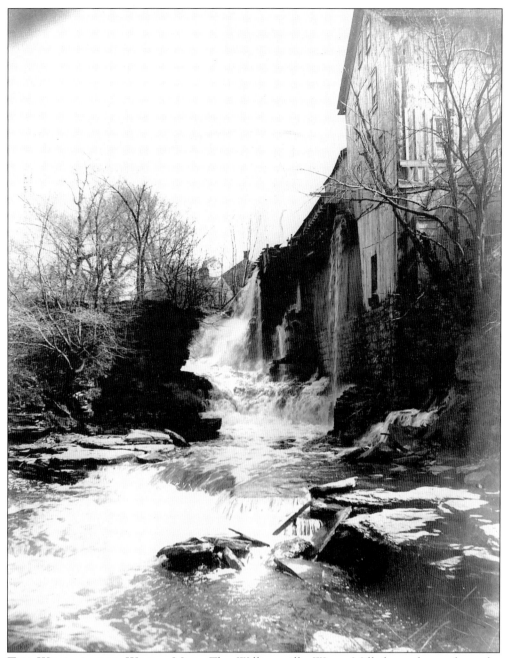

THE WILLIAMSVILLE WATER MILL. The Williamsville Water Mill, here shown from the Ellicott Creek falls side, was built in 1811 and is the oldest operating business in Erie County. Built in an area that came to be called the Glen, it was powered by the waters of Ellicott Creek cascading down over the Onondaga Escarpment of southern Amherst to the lower, often marshy, lands of the central and northern areas of the town.

IMAGES
of America

AMHERST

Joseph A. Grande

ARCADIA
PUBLISHING

Copyright © 2004 by Joseph A. Grande
ISBN 978-0-7385-3680-4

Published by Arcadia Publishing
Charleston SC, Chicago IL, Portsmouth NH, San Francisco CA

Printed in the United States of America

Library of Congress Catalog Card Number: 2004108753

For all general information contact Arcadia Publishing at:
Telephone 843-853-2070
Fax 843-853-0044
E-mail sales@arcadiapublishing.com
For customer service and orders:
Toll-Free 1-888-313-2665

Visit us on the Internet at www.arcadiapublishing.com

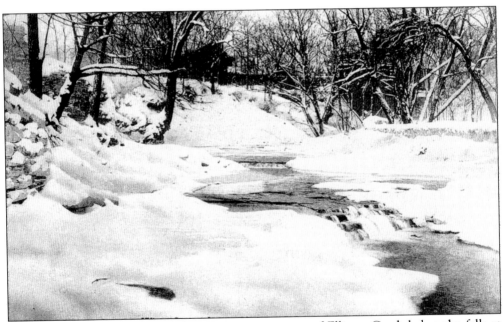

ELLICOTT CREEK IN WINTER. This serene winter scene of Ellicott Creek below the falls at Williamsville belies the fact that the creek, flowing through the town southeast to northwest, was a major geographical feature that influenced Amherst's development. It attracted both early settlement and industry to its shores.

CONTENTS

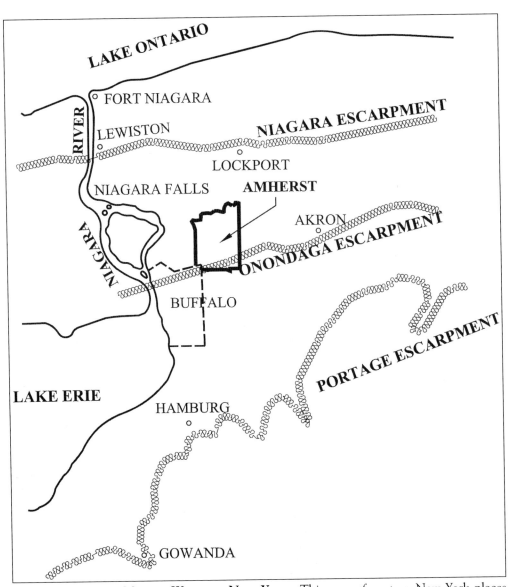

A Topographical Map of Western New York. This map of western New York places Amherst within the topographical context of the region. Note that the Onondaga Escarpment, a 30- to 70-foot-high limestone bluff running from Albany to the Niagara River, cuts through the southern section of the town. The first major road through town, the Buffalo Road, now Main Street (Route 5), ran along the top of the escarpment. It was here that the settlement of Amherst began.

INTRODUCTION

Amherst recounts the amazing tale of a community with an abundance of nature's blessings that began as a pioneer settlement around a natural power source, the Ellicott Creek falls. The pioneer era was interrupted by the arrival of a large American army encampment in the village of Williamsville during the War of 1812. Unlike the nearby village of Buffalo, which was burned to the ground by British invaders, Williamsville was never invaded by the feared enemy. Young officer Winfield Scott—later a hero of the Mexican War, a candidate for the presidency of the United States, and commander of the Union Army at the beginning of the Civil War— served as commander here.

Following the War of 1812 and throughout the 19th century, Amherst was a prosperous farming community with grain fields, fruit orchards, vegetable acreage, and livestock including cows, sheep, and horses. Racehorses were bred to run in area racetracks including one in Amherst: the Williamsville Driving Park. Amherst's agricultural production served surrounding communities, including the rapidly growing city of Buffalo to the west, which had begun as a village about the same time as Amherst's village of Williamsville. By 1900, Amherst's population of 4,223 was far outstripped by its major market, Buffalo, whose population had grown to approximately 400,000 thanks to its location at the juncture of the Erie Canal and Great Lakes and its role as a major railroad center.

As modern modes of transportation like trolleys and trains replaced carriages and stagecoaches, people escaped crowded city conditions and the necessity of living near where they worked. The very wealthy came first, at the dawn of the 20th century, building their large estates, and the modest to more affluent citizens of western New York moved into Amherst along Main Street later, creating comfortable, attractive suburban enclaves in the southwest corner of the town, nearest to Buffalo. That suburbanization continues to this day all over the town of Amherst.

Amherst, in the last half century, has become more than a suburb of Buffalo. It has become a major economic, educational, and medical hub in western New York. Rosary Hill College, now Daemen College, was founded there in the late 1940s, and Erie Community College was built in the 1960s. The new campus of the State University of New York at Buffalo, with its 20,000 students, arrived in the 1970s. The university is a major employer in western New York and has changed the nature of the town population, resulting in increased diversity.

The healthy character of the local business climate has attracted major corporate headquarters and regional offices. The decision of the giant auto insurance company, GEICO, to locate a

regional headquarters in Amherst, employing 2,000 people, was a major coup for the town. Further, the main offices of corporations such as National Fuel Gas, western New York's main public natural gas provider, are located here, as are the headquarters of many regional business enterprises.

The opening of the Millard Fillmore Suburban Hospital in the 1970s encouraged the arrival of numerous medical interests including doctor's offices, medical laboratories, and hospital satellites. Many facilities designed to meet the needs of senior citizens, from residences for the well-aged to assisted-living facilities to nursing homes, are also located here, as are several comprehensive senior citizen campuses.

A newly opened senior citizens center, as well as youth facilities and programs, makes the quality of life in Amherst second to none. Cultural centers like the Amherst Museum are complemented by Erie County's leading town library system, top-notch series of public and private schools, and enviable recreation program. The presence of a highly capable law enforcement corps has led to the community's designation as the "safest community" in the United States.

Amherst reveals in pictures and words a truly compelling story. The town is blessed by geography, hardworking citizenry, creativity, and an emphasis on education. Its residents are focused on other fundamental values—social, economic, religious, and political—that have contributed to the development of a vibrant community. Although not without its problems, be they traffic, budgetary, zoning, construction development, or otherwise, the town continues to strive to maintain its reputation as a community with an inviting business climate and a fine quality of life.

The main sources for this book are the collections of the Amherst Museum. Without the support and encouragement of the entire staff, especially executive director Lynn Beman and librarian Toniann Scime, work on this volume would have been very difficult. Quick access to library resources and the rich image collections of the archives made preparing *Amherst* so much easier. I would be remiss if I did not express my appreciation to the Amherst Museum Board of Trustees and to town supervisor Susan Grelick for enthusiasm and cooperation in the execution of this project.

—Joseph A. Grande, Ph.D.

One

PIONEER DAYS

What is now the town of Amherst was originally part of the Dutch-owned Holland Land Purchase, a tract of over three million acres. Surveyor Joseph Ellicott of Pennsylvania was hired by the Holland Land Company owners to survey their lands and then was appointed resident agent on the purchase to direct land sales. Although he made his headquarters in Batavia, to the east, Ellicott had direct ties to what became Amherst. His brother Benjamin, and Benjamin's business partner, John Thomson, were the first owners of the lands around the falls at what became Williamsville. Although not much progress in developing the site occurred during their tenure, Thomson built the first building there, for years called the Evans House, and Benjamin Ellicott made Williamsville his residence. The Evans name comes from David Evans, Ellicott's nephew, who became involved in harnessing falls power with his partner, Jonas Williams, the real first developer of the area. The Evans family moved to Williamsville, and generations of Evanses lived there. Although growth in the settlement was temporarily halted by the War of 1812, new pioneers began to arrive following that struggle.

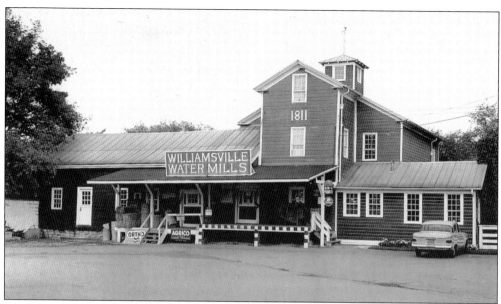

THE WILLIAMSVILLE WATER MILL. The Williamsville Water Mill was built by Jonas Williams in 1811. The most familiar landmark in Amherst, it was operated first as a grain mill and later as a cement mill by various owners. The village that grew around it was first called Williams' Mills and later Williamsville. In 1947, Daniel and Grace Niederlander purchased the mill and restored it as a grain mill. Grace Niederlander was a member of the Miller family who ran the mill for many years. The mill is still in operation today.

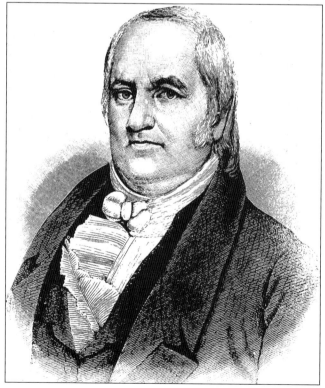

JOSEPH ELLICOTT. Joseph Ellicott was the chief surveyor and then resident agent in charge of land sales for the Holland Land Company, a group of Dutch financiers who lent money to the American government during the War of Independence. When repaid, the company bought the Holland Purchase. Under Ellicott's direction the first land sales in what now is Amherst were made around the Ellicott Creek falls, which is not surprising given its ample available waterpower.

BENJAMIN ELLICOTT. Benjamin Ellicott, brother of Joseph Ellicott, joined John Thomson in buying acres of land around the Ellicott Creek falls, a natural mill site. He later lived in Williamsville and represented the area in the U.S. House of Representatives. A nephew, David Evans, also came to Williamsville with his family.

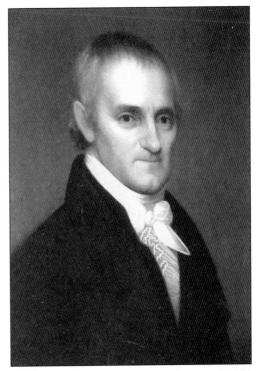

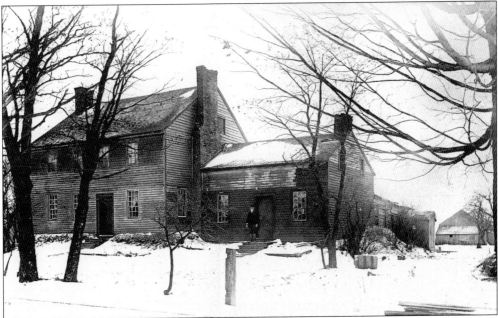

THE EVANS HOUSE. The Evans House, built in 1799 by John Thomson, a partner of Benjamin Ellicott, was the first structure in what is now the village of Williamsville. It served first as an inn and later as a residence and military headquarters during the War of 1812. The house got its name from the Evans family, relatives of Joseph Ellicott, Holland Company land sales resident agent. Owned by the Evans family until 1925, it was located at Main Street and Oakgrove Drive.

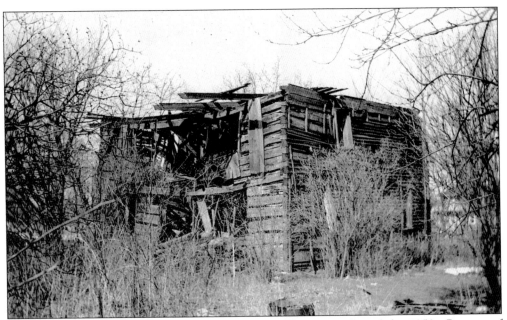

THE LAST DAYS OF THE EVANS HOUSE. The Evans house stood until the 1950s. Because of its historical significance to Amherst and its reputation as the oldest building in Erie County, attempts were made to rehabilitate it as a historic site and library. Unfortunately, those attempts failed, and the house was demolished in 1955, shortly after this picture was taken.

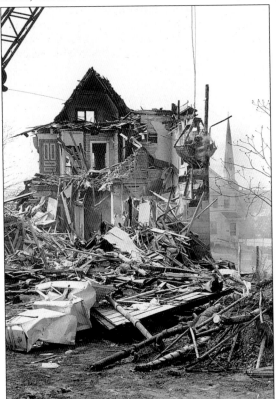

THE JONAS WILLIAMS HOUSE. Jonas Williams, perhaps the richest man in the settlement that was to bear his name, concentrated on endeavors to develop and operate mills, a tannery, furnaces, and carding works. His home was the social center of the area; there, he and his charming wife, Elizabeth, entertained leaders of the frontier community. Located on high ground on the east side of Cayuga Road, his home was surrounded by gardens and a picket fence. Efforts to save it were to no avail, and in 1969 it was torn down, as shown here.

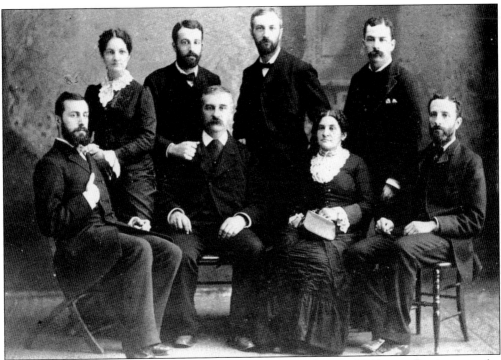

THE JOHN LONG FAMILY. John Long and his family family were Williamsville pioneers who built a sawmill near what is now Union Road and Main Street. Lured by low land prices, they moved to Fort Erie, across from Buffalo in Canada, where they lived for five years. When events leading to the War of 1812 created hostility toward Americans living on the Canadian side of the Niagara River, and heavy taxes were levied on them, they moved back to Williamsville, where they played an active role in community life for generations.

WINFIELD SCOTT. Col. Winfield Scott directed American army training in Williamsville during the winter of 1813–1814. After the Battle of Lundy's Lane in Canada, a wounded Scott, along with wounded prisoner-of-war British commander Phineas Riall, were brought to Williamsville, where they stayed in the Evans house for a time. Riall was later exchanged, and Scott advanced in the military to the rank of general and became a hero in the Mexican War of 1846–1848. He commanded forces in Buffalo during a war scare in the late 1830s occasioned by American aid to leaders of the 1837–1838 Canadian rebellion, led by William Lyon Mackenzie.

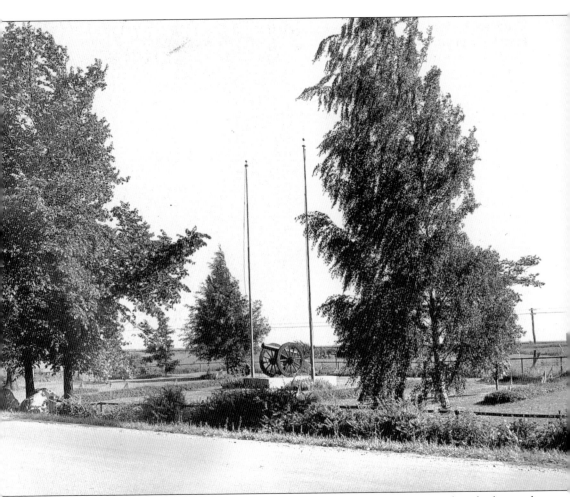

THE WAR OF 1812 CEMETERY. Many of the sick and wounded soldiers treated in the hospital complex on Garrison Road died of fever, acute rheumatism, or typhus. More than 200 soldiers, including an unknown number of British prisoners, were interred in a cemetery established a quarter mile south of the hospital, along Ellicott Creek. This long-neglected War of 1812 cemetery attained new prominence in 1936, when the Canadian Legion of Fort Erie, Ontario, presented the cemetery with an American field piece captured during the War of 1812. It was placed in the center of the cemetery between one flag pole flying the British flag and one flying the American flag.

TIMOTHY S. HOPKINS. Timothy S. Hopkins, a pioneer settler in Amherst, joined the local militia and served as a brigadier general during the War of 1812. When he first came from western Massachusetts, he lived in what is now Clarence, raising wheat and managing a local mill. He wed Nancy Kerr at the Evans house in 1804 in the first marriage of record in Erie County. The newlyweds moved to a large log house on a farm that included land upon which the present Amherst High School now stands, in Snyder. Serving in the government while Amherst was still part of the town of Clarence, Hopkins was chosen the first supervisor of the newly formed town of Amherst in 1818. After serving several terms as supervisor, he became a justice of the peace, a position he held for 32 years.

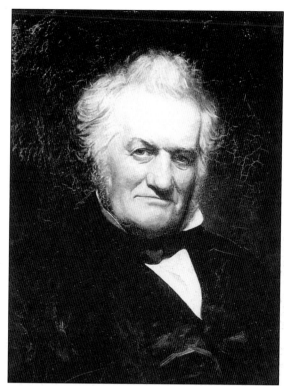

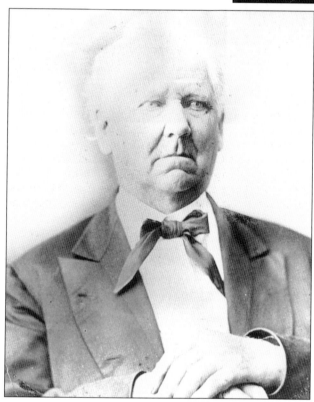

ALEXANDER HITCHCOCK. Alexander Hitchcock, a veteran of the War of 1812, was a leader in the newly formed town of Amherst from the beginning. He held positions such as member of the town board, commissioner of education, and commissioner of highways. A resident of the southern part of Amherst, he became the first supervisor of the town of Cheektowaga when that area became a separate township in 1839.

LORD JEFFREY AMHERST. Lord Jeffrey Amherst is likely the indirect source of the name selected for the newly formed town of Amherst in 1818. Although this is difficult to verify, many of the settlers in the area were from western Massachusetts, where there was already a town called Amherst, named in his honor. Lord Amherst commanded the British army during the French and Indian War in North America, during the 1750s and 1760s. The royal government gave him a 20,000-acre land grant in New York for his service, but he never took up residence there, returning instead to England. When the American War of Independence broke out, he refused to command English forces to put down the rebels. He later served as a commander in the wars against France during the French Revolution.

Two

A Land of Farms

Early immigrants to Amherst came from a variety of places and engaged mostly in farming. The Native American Senecas never established long-term settlements but rather crossed the area hunting, fishing, and extracting limestone fragments from the Onondaga Escarpment for use in their weapons and other implements. At the end of the 18th century and into the 19th century, settlers came from Massachusetts, Vermont, and Connecticut, seeking land superior to the rocky soils of their native states. They were soon joined by Germans whose origins varied. Some came from the Pennsylvania Dutch country; others came directly from Europe. French settlers joined Germans coming from the border provinces of Alsace-Lorraine. With the building of the Erie Canal came the Irish who largely built the canal. Yet the preponderance of settlers were hardworking Germans, who settled all over the town and were instrumental in turning the marshlands of the northern Amherst into rich farming terrain. Thus, names such as Fiegel, Spoth, Fischer, and Dettmer were familiar ones in the town.

By the end of the 19th century, wealthy businessmen from nearby Buffalo, like John Blocher and Charles Lautz, arrived to try their hand at establishing model farms. Farming enterprise remained a major part of the Amherst economy up to World War II and even after. The birth of suburban enclaves, however, and the rise of strip malls and business parks gradually encroached on farmlands and made farming a smaller and smaller part of the Amherst economy.

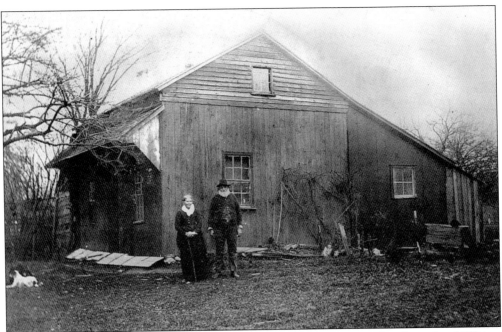

THE HARDYS. The Hardy house was built in 1839 on Sweet Home Road north of Ellicott Creek. Located in the northwest corner of Amherst, it was situated near what was called the French Settlement, where a number of French immigrants took up the land. Henry Hardy and his wife in front of their rather primitive house. Pioneers like the Hardys weathered rugged living conditions in the early years of settlement, clearing the land of trees and breaking up the virgin soil for planting.

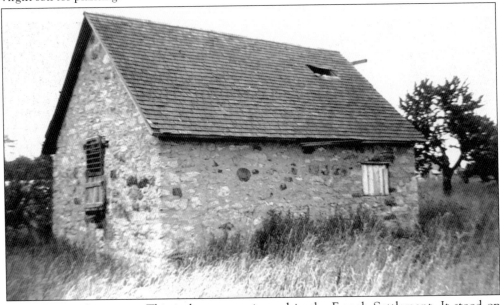

THE MULLEN ICEHOUSE. This icehouse was situated in the French Settlement. It stood on the Mullen farm near Skinnerville Road and was a typical example of how farmers stored their ice, much of which, in early years, was cut from frozen creeks and hauled for storage in stone buildings such as this.

18

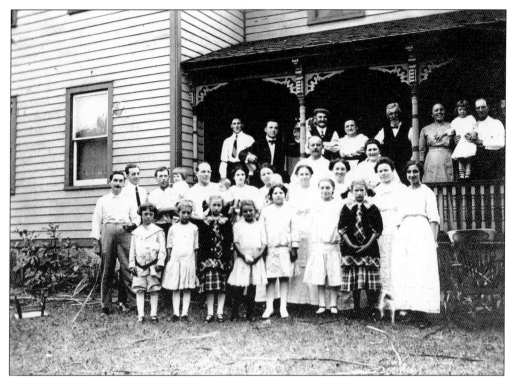

THE FIEGEL FAMILY. Large families were typical in rural America in the 19th and 20th centuries. Shown here are members of the Fiegel family in front of their homestead on New Road in Swormville. The patriarch of the family, Joseph Fiegel (back row, fourth from the right), was a highly respected veteran of the Civil War.

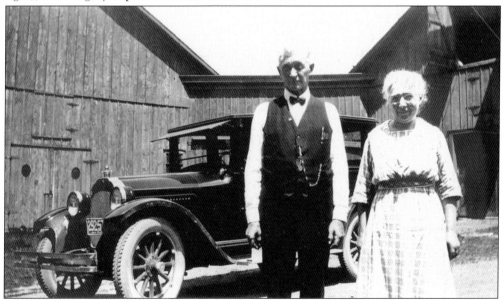

THE BECKERS. Farm life was still widespread in Amherst until World War II. Mary and Henry Becker stand in front of their barn on Sweet Home Road in July 1924. The automobile indicates that their farming enterprise was a profitable endeavor.

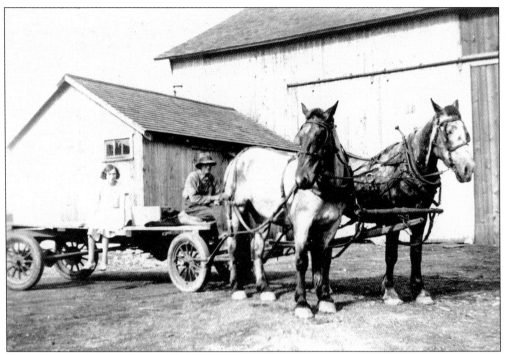

THE WAGNER FARM. This *c.* 1930 picture of the Wagner farm on New Road shows the flavor of rural life in Amherst well into the 20th century. The people in the picture are unidentified. Note the well-kept barn and horse-drawn flatbed cart, used to haul in the harvest.

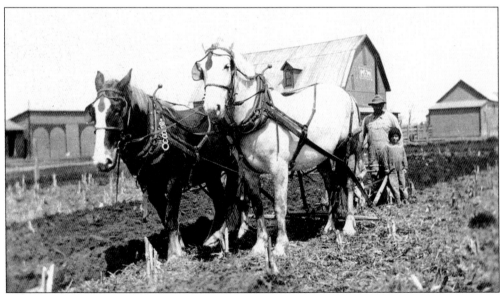

SPRING PLANTING. Spring planting was always an important occasion in rural Amherst. Shown here is the beginning of spring planting on the Becker farm on Sweet Home Road, with Henry Becker Sr. and a grandchild standing next to a horse-drawn plow.

20

A Pickle Patch. Among the crops planted in Amherst and sold to local markets like Buffalo were pickles. Pictured is Ceil Thuman in the pickle patch on the family farm on New Road. Children were an important asset on the farm, carrying out essential chores during the course of the growing season.

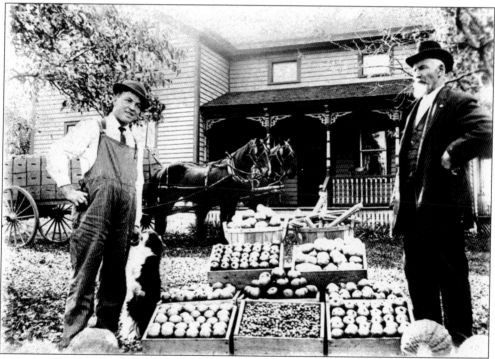

A Fiegel Harvest. The rich virgin lands of Amherst typically produced abundant harvests. This is well demonstrated by this picture of a harvest from the Fiegel farm on New Road in Swormville. Standing in front of the Fiegel homestead next to boxes of harvested produce are Charlie Fiegel (left) and Joseph Fiegel. Note the variety of produce raised on the farm.

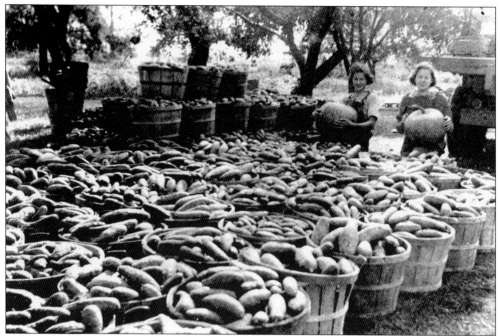

A CUCUMBER HARVEST. Pictured here are bushels of cucumbers, behind which stand Delia and Mary Spoth, holding pumpkins. The Spoth family owned farmlands in northeast Amherst on Transit Road, as well as across the road in Clarence.

SHUCKING OATS. Harvest time on the Spoth farms saw many of the Spoth children shucking oats. Pictured are, from left to right, Lester, Mary, Don, Carl, Ray, Delia, and Alene. This is a typical scene depicting children in rural Amherst involved in the family farming enterprise.

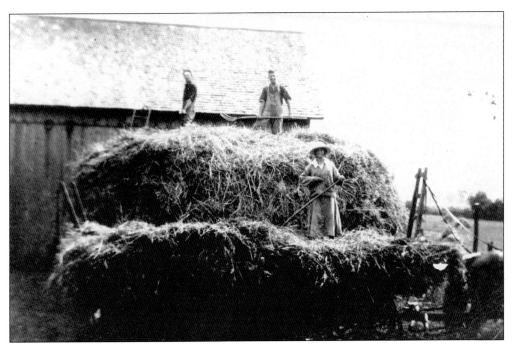

THE HAY HARVEST. The hay harvest was vital to livestock production, which was an important part of the Amherst agricultural economy into the 20th century. Shown are Henry Dettmer (left), his son Bob, and his wife, Irene, c. 1931.

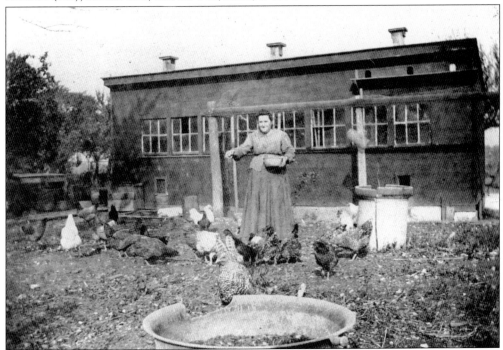

CATHERINE FISCHER. Catherine Fischer feeds chickens raised at the Fischer home, near Harlem Road and Main Street, in the settlement there, first called Snyderville. The Fischer family ran a number of business enterprises in rural Snyder.

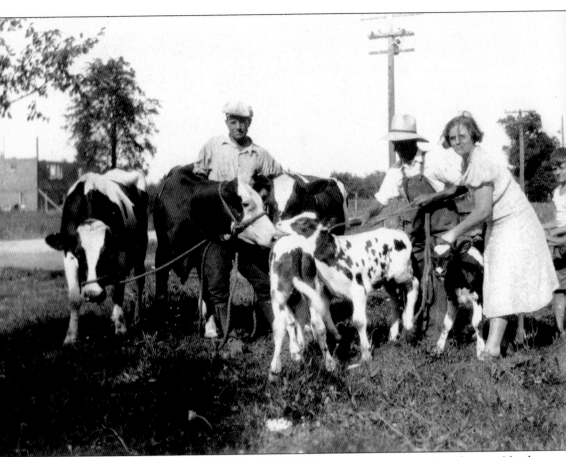

SPRING CALVES. The Dettmers carefully tended to their spring calves on their farm on North French Road. Replenishing the dairy herds was a serious concern in Amherst in the late 19th and early 20th centuries as dairying became more and more important to the Amherst agricultural economy.

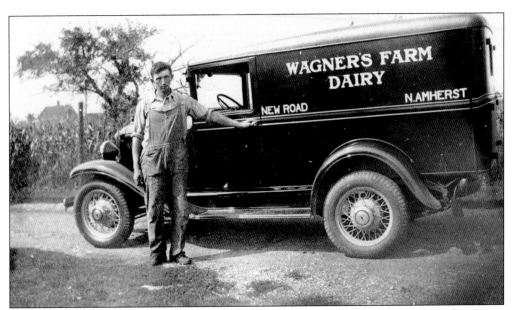

AMHERST DAIRIES. Dairies were a natural outgrowth of the increase in dairy cattle farming in the late 19th and early 20th centuries. Shown above is a Wagner Farm Dairy truck with an unidentified young man *c.* 1930. The farm was located on New Road in north Amherst. Below are children sitting on the running board of a North Amherst Dairy delivery truck. The dairy farm on Scholelles Road, owned by Howard Rogers, also raised beef cattle and chickens.

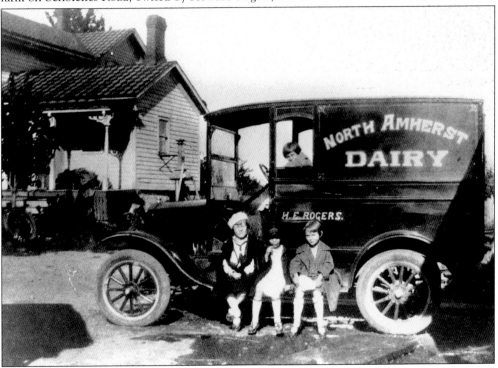

HORSE FARMS. Raising horses became an important enterprise in Amherst around the dawn of the 20th century. In the Ransom Creek area, the Gephardt family owned the Brookside Stock Farm. People came from all over western New York to bid in the horse auctions held at the farm.

BLOCKER'S STOCK FARM. Businessman John Blocher bought tracts of land on Evans Road, as well as elsewhere in Amherst. In addition to being a philanthropist, he ran a stock farms (pictured) and had other agricultural enterprises including orchards with 2,500 apple trees, 400 pear trees, and 3,000 grapevines. His attempts to grow cranberries failed.

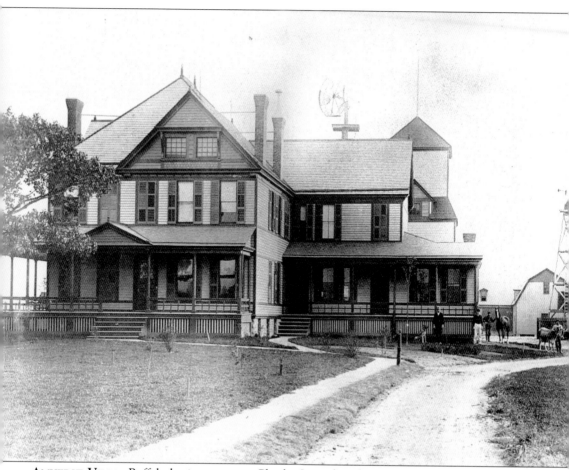

AMHERST VILLA. Buffalo business tycoon Charles Lautz bought a 249-acre estate in Amherst 10 miles from Buffalo on the south side of Main Street, just east of Williamsville. On this estate, named Amherst Villa, he built an impressive summer residence and more than a dozen structures including homes for workmen, stables for cattle and horses, grain storage bins, and poultry and dairy houses. Amherst Villa achieved a national reputation as a model enterprise that was, according to one national magazine, "an admirably conducted farm."

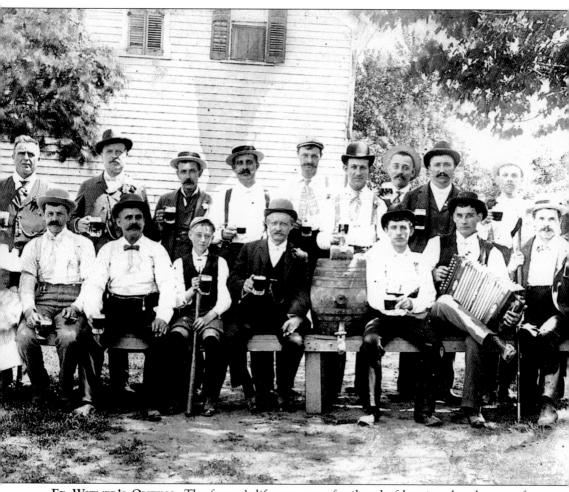

ED WITMER'S OUTING. The farmer's life was one of toil and of braving the elements from sunrise to sunset. It was not, however, without its times of fun and recreation. In 1900, Ed Witmer's farm in Eggertsville was the site of an outing organized by a *Verein,* or club, of German-speaking Amherst settlers. Many Germans settled in the town in the 19th century, and public notices were published in both English and German to accommodate them.

Three

THE VILLAGE CENTER AND HAMLETS

Although the first settlement in Amherst developed around the Ellicott Creek falls at Williamsville, it was but one of several that sprang up around the town. First came Eggertsville, Snyder, and Snearly's Corners along the Buffalo Road (Main Street), all of which arose at important crossroads such as Eggert, Harlem, and Transit Roads, respectively, as well as Swormville to the north on Transit Road. Later, others such as Transit Station just south of Swormville, Getzville in central Amherst near the hamlet of Amherst Center, and Vincent's Corners in the northwest part of the town developed along the new railroad line built in the 1850s through the central part of the town. Not to be ignored was the little hamlet of Pickard's Bridge, located on Tonawanda Creek where the creek served as part of the Erie Canal. Most of these hamlets arose to serve the surrounding farmers with general stores, post offices, mills, and blacksmith shops. Williamsville was the only settlement that incorporated as a village in 1850. It was for many years the center of Amherst's political and economic life.

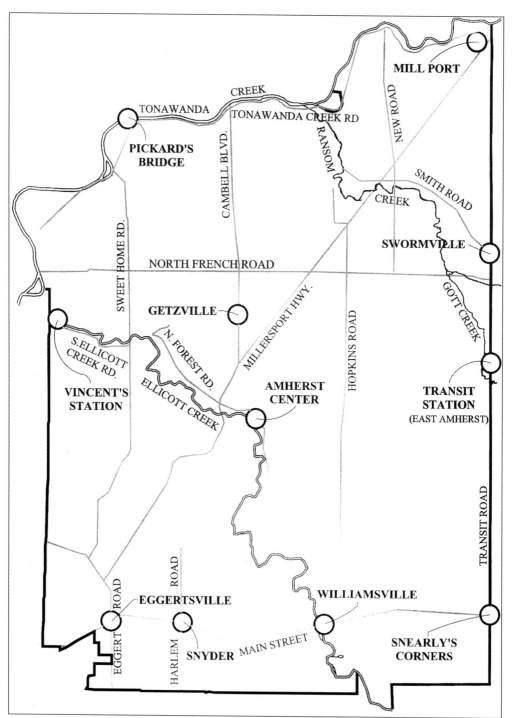

A Map of Amherst with Hamlets. Amherst is distinctive in that it had a large number of hamlets as compared with other towns in western New York. The hamlets were located at major crossroads or along railroad lines.

TIMOTHY A. HOPKINS. Timothy A. Hopkins, eldest son of Timothy S. Hopkins, first supervisor of Amherst, originally moved to Ohio to pursue business interests. He returned to Amherst in 1844 where he acquired mills around the falls at the Glen, and served as a lawyer, justice of the peace, town supervisor, sheriff of Erie County, and New York State assemblyman. In his later years, he wrote the first Amherst history at the request of former Pres. Millard Fillmore, a founder and first president of the Buffalo Historical Society.

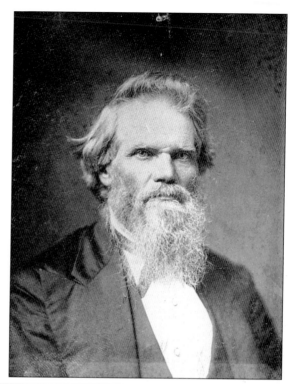

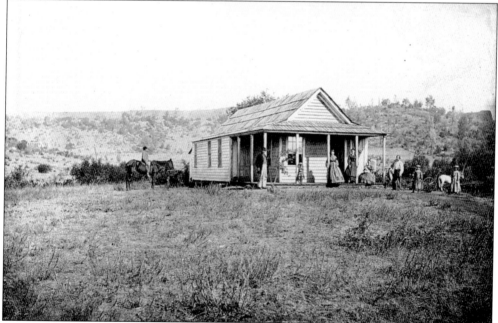

THE REISTS. John Reist and his family were among the first settlers near the falls at Williamsville, where he bought 196 acres. A Mennonite and a veteran of the War of 1812, he was ordained a minister in 1836 and preached for over 40 years at the Mennonite Meeting House, which was erected in 1834 and still stands today at the corner of Main Street and North Forest Road. Shown here are the Reists in front of their early pioneer residence.

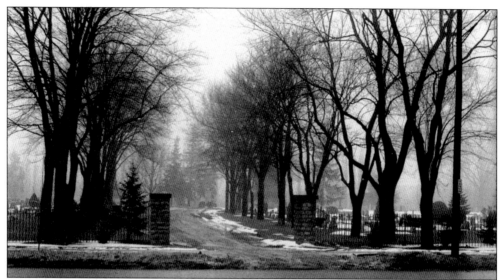

THE WILLIAMSVILLE CEMETERY. The Williamsville Cemetery began as a burial place set aside by the Long family, devout Mennonites, for members of their family. Located on the north side of Main Street at the west end of Williamsville and east of the Mennonite Meeting House, it was soon open for burials of all village residents.

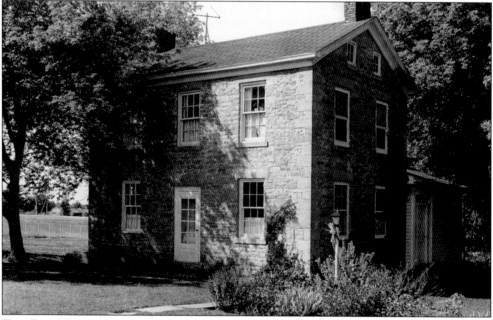

THE FOGELSONGER HOUSE. John Fogelsonger bought land at the west end of Williamsville c. 1818. There he first built a log cabin and then a typically German stone residence to house his wife and six children. After adding a barn and chicken house, he launched a prosperous limestone quarry business that provided building materials for major projects such as the Erie Canal and the breakwater at Buffalo harbor, as well as area schools, homes, bridges, roads, and mills. This Williamsville quarry operated for many years and was destroyed with the building of the intersection of the New York State Thruway (Interstate 90) and the Youngmann Highway (Interstate 290).

THE KIBLER STONE HOUSE. German immigrant George Kibler came to Amherst and settled in the center of the town near present-day North Forest and Heim Roads. He first built a plank house on the west side of North Forest Road near Ellicott Creek in the 1830s. It was not long before he, like many other Germans, constructed a house of locally quarried limestone. The house still stands at the corner of what is now Swanson Terrace and North Forest Roads.

THE BAGGARD HOUSE. The French Settlement, in northwest Amherst, included the Baggard home, built by Francis Baggard, who came from Alsace-Lorraine on the Erie Canal in 1832. The home was located on South Ellicott Creek and Sweet Home Roads, where Baggard first built a log house on a 62-acre farm. The French Settlement, later called Vincent's Corners, included many settlers from the same European villages, such as the Vincents, Sardellets, Metros, and Dumanois. Some German families from the Alsace-Lorraine region, located on the border between Germany and France, also settled in the area.

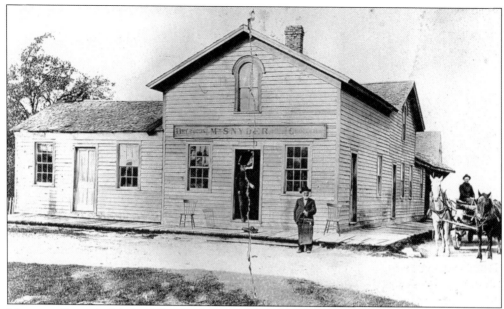

MICHAEL SNYDER. Michael Snyder (pictured) ran a store and post office, which he founded with his cousin John Schenck, on the corner of Main Street and Harlem Road. The hamlet Snyderville grew around the intersection, named after Snyder, who was the first postmaster. Other businesses soon sprang up, including inns, feed stores, blacksmith shops, potteries, and wagon works to serve the nearby farmers.

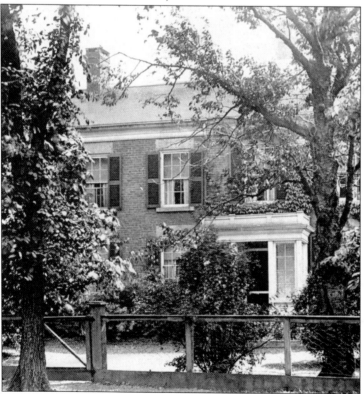

THE SCHENCK HOUSE. The Schenck family first came to Amherst in 1821 and lived in a frame house at the corner of Main Street and Harlem Road. Later, they bought land from Timothy S. Hopkins and built a house at Main Street and Amherstdale Road with bricks from local brickyards. The house remained in the possession of the Schenck family until 1958.

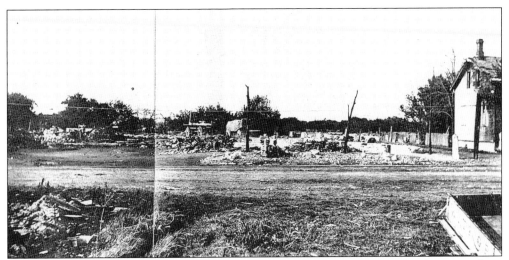

THE SNYDERVILLE FIRE. Snyderville, or Snyder as it came to be called, suffered an incendiary catastrophe in 1905, when a fire, originating in a nearby barn at the Main Street–Harlem Road intersection, quickly swept through the entire area, destroying 12 buildings, including barns, blacksmith shops, and other businesses critical to the Snyder economy. The fire also burned stores of grain and a number of livestock.

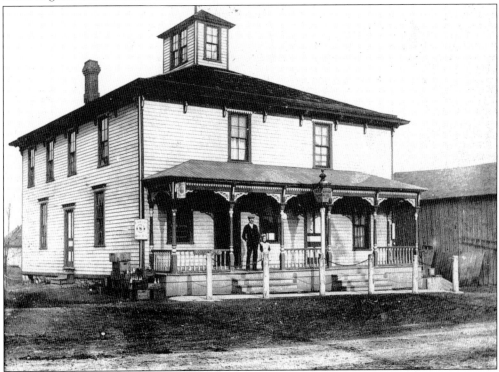

THE CUTLER HOUSE. The Cutler House in Getzville, dating to the 1830s and 1840s, was variously a store, a hotel, a residence, and a post office. The second floor served both as a courtroom and a dance hall. The hamlet of Getzville got its name from brothers Franklin and Jacob Getz, who established milling and lumber businesses there. The coming of the Canandaigua and Niagara Falls Railroad to the hamlet at mid-century greatly advanced its prosperity.

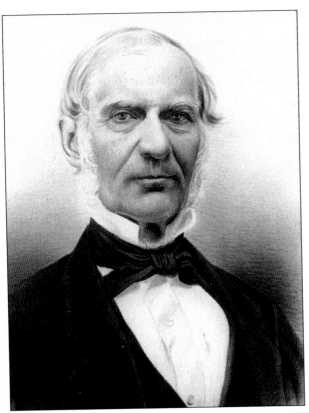

BENJAMIN MILLER. Benjamin Miller was born in Eggertsville, and as a child fled with his mother eastward toward Batavia during the War of 1812 for fear of a British attack on Williamsville, a major American military center. In 1839, he moved to Williamsville, where he opened a dry goods store at the corner of Main and Mill Streets. He greatly expanded his business interests and became a prominent leader, serving as the first president of the newly incorporated village of Williamsville in 1850.

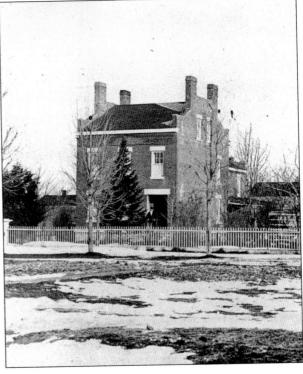

THE MILLER RESIDENCE. The Benjamin Miller residence, built *c.* 1850 at the corner of Main and North Ellicott Streets, became a major center of social, business, and political activity in Williamsville. Among the friends who visited Miller's home were future Pres. Grover Cleveland. In 1866, Miller bought the mills around the falls and upgraded them considerably. He also opened new limestone quarries and invested in other mercantile enterprises.

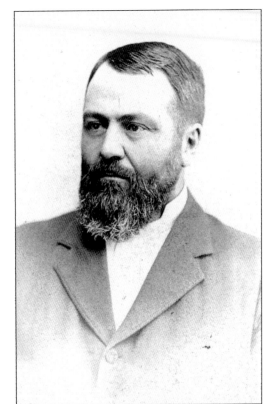

DR. HIRAM TRULL. Hiram Trull was born in 1842 in Sheldon, New York, and came to Buffalo to study medicine at the Buffalo Medical College, the first unit of the new University of Buffalo. He received his medical diploma from the university's first chancellor, former Pres. Millard Fillmore, and then moved to Williamsville, where he practiced medicine until he retired. He was active in town and village affairs, serving as the first health officer in the area. He operated out of his imposing house (below), at 40 South Cayuga Street.

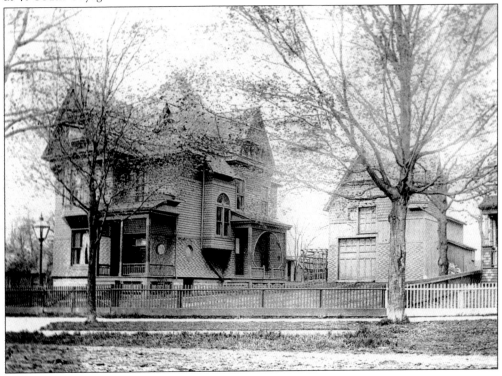

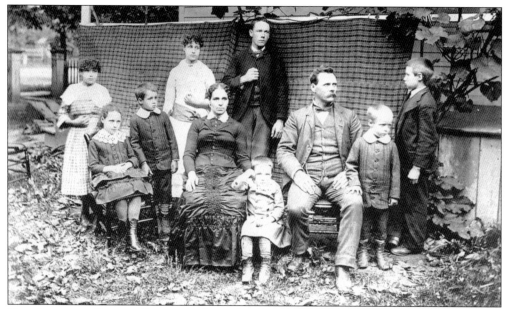

THE CHALMERS FAMILY. Born and educated in Scotland, James Chalmers came to the United States in 1872, and in 1873, founded a gelatin business in Williamsville that grew into the largest business enterprise in Amherst, with many international connections. He helped found several banks, and—because of his interest in horse-racing—the Williamsville Driving Park. Between 1894 and 1920, he served a number of terms as mayor of the village. With a large family, and an interest in education, he served on the board of education of his local school district.

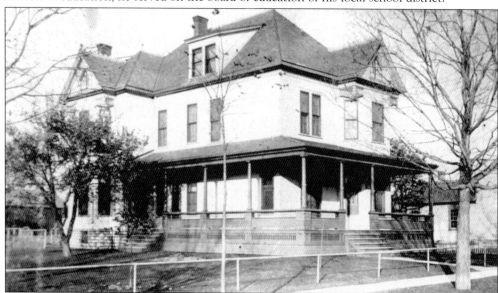

THE CHALMERS RESIDENCE. The large Chalmers residence, at Main and North Ellicott Streets, was the scene of many social events. One such event was a celebration of James and Helen Chalmers's 25th wedding anniversary. The house and grounds were elegantly decorated with palms, evergreens, and flowers. After receiving their guests in a spacious reception room, the Chalmers were joined for supper by their 8 children and 125 guests in a tent erected on the front lawn and decorated with Chinese lanterns.

THE ADAM RINEWALT RESIDENCE. Adam Rinewalt (shown in front of his residence) was born in Williamsville in 1849 but moved to Wisconsin to become a printer's apprentice. He returned to western New York in 1870 to join the staff of a Buffalo newspaper and, in 1879, came home to Williamsville to found the weekly *Amherst Bee*, which he ran until 1907. Active in village business and political affairs, he served as mayor and postmaster. He was also instrumental in bringing the first telephone line to Amherst, installed in the offices of the *Amherst Bee* on Main Street in the village.

THE PHILIP SNYDER RESIDENCE. Philip Snyder moved from Snyder to Williamsville where, in 1877, he built an elegant 14-room Italianate brick home. Involved not only in business, Snyder also served on the local board of education and helped to found the private Williamsville Classical Institute, which later became a public school. Shown here is his daughter, Rose, whose wedding to Herman Geiger was celebrated with 100 guests in the Snyder home. The newlyweds received their guests under a canopy of evergreens and roses to commence daylong festivities with music and dancing.

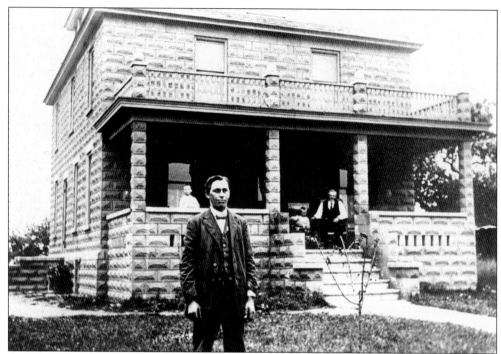

THE LEISING RESIDENCE. John Leising, a leading businessman in Swormville, invented a machine to make hollow concrete blocks, and for years blocks from his factory were used to serve as foundations for many buildings in the area. He built a unique home for his family on Transit Road, constructed completely of concrete blocks. He was the first resident of Swormville to own a car and was active in the community and church affairs, especially at St. Mary's Roman Catholic Church, where he served as school bandleader.

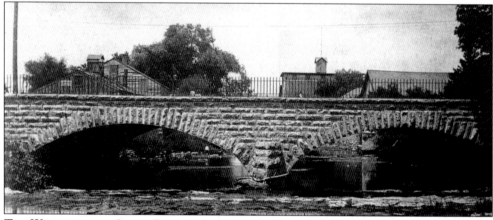

THE WILLIAMSVILLE STONE BRIDGE. Stone was used to remedy the problems caused by various wooden bridges over Ellicott Creek on Main Street. Spring floods frequently washed them away. As more and more stagecoach and freight wagon traffic came down Main Street, either local traffic or traffic to and from Buffalo, the situation became intolerable. Thus the decision was made to build a stone bridge, which was completed in 1882. Much of the stone came from local quarries. The opening of the bridge was an occasion for great celebration. Its construction was well timed, as trolley tracks were soon built to carry the new Williamsville trolley. It was not long before automobiles were crossing the span.

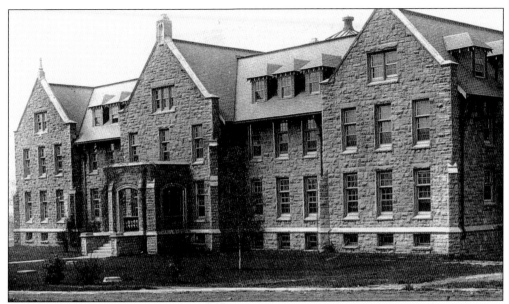

THE BLOCHER HOMES. Philanthropist John Blocher promoted social welfare agencies in Amherst even before the beginning of the 20th century. Although he was a Methodist, in 1891, he donated 100 acres of land between Mill and Reist Streets to the Catholic Sisters of St. Francis with the provision that they establish a home for the aged. He then founded a Methodist-sponsored facility for the elderly. The impressive stone Gothic-style Blocher Homes were meant to serve the elderly in their declining years. The facility was open to people over 50 years of age who could come and go as they pleased. Medical care was available when needed.

THE BLOCHER PAVILION. John Blocher was involved in the operation of the Williamsville Trolley. That trolley brought thousands of people to the Blocher Park Pavilion, on Evans Street north of Main Street. Locals, as well as people from Buffalo and surrounding towns, flocked here to picnic and to enjoy fruit produced by Blocher's nearby orchards.

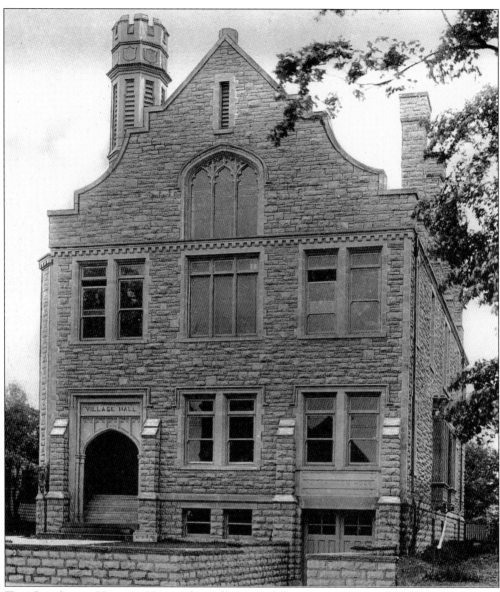

THE OLD STONE VILLAGE HALL. The trolley passed the imposing stone old village hall built in 1908 to house the governments of both the village and the town. The building also included a one-room library and a fire hall. Land for the structure was donated by the Hutchinson family from acres near their home on Main Street. The Hutchinsons also gave money for building the fire company, which was renamed the Hutchinson Hose Company, a name it retains today.

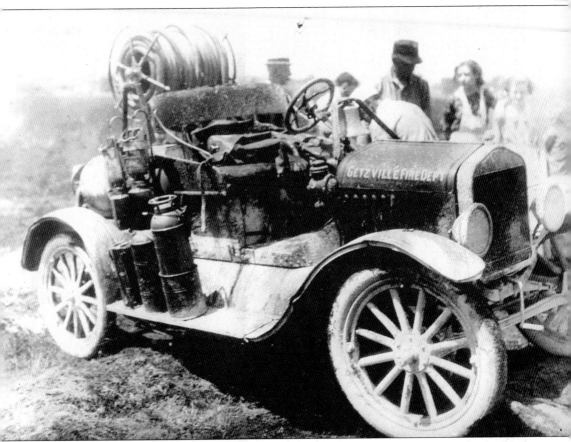

THE GETZVILLE FIRE COMPANY. The Getzville Fire Company came into being as the result of a series of barn fires. A meeting was held at the Cutler House, then called Kobel's Hotel, where concerned citizens decided to purchase a piece of land next to the railroad tracks to build a fire hall. The company's first piece of equipment was the Model T chemical truck shown here. Money was easily raised by direct donations and fund-raisers like picnics and dances.

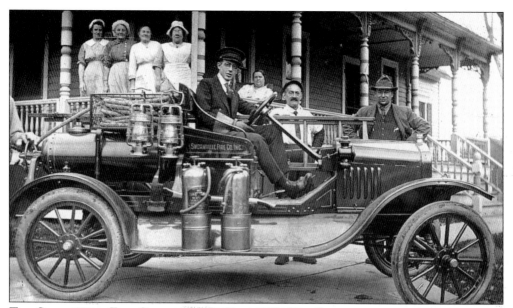

THE SWORMVILLE FIRE COMPANY. The Swormville Fire Company, organized in 1918, raised money by public subscription, as well as proceeds from picnics, dances, and card parties. These funds were used to build a fire hall and to buy the first piece of firefighting equipment, this Ford touring car, converted into a chemical tank truck at a local blacksmith shop.

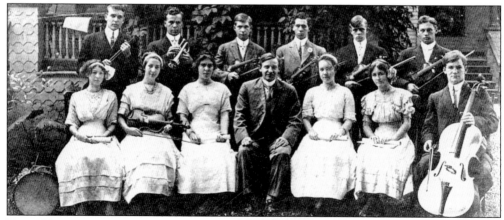

THE WILLIAMSVILLE SYMPHONY. The village of Williamsville—the political, social, and economic center of Amherst—reflected its cultural identity in 1910 through the Williamsville Symphony, a group of musically talented young people who performed at missions and churches in the area.

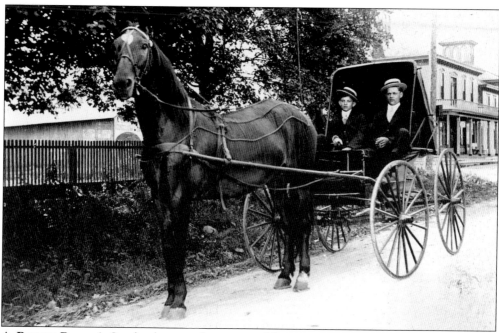

A Buggy Ride. A Sunday buggy ride is enjoyed by two young men in Swormville. In the background is Lapp's Hotel, a popular stop for people traveling to Lockport on Transit Road.

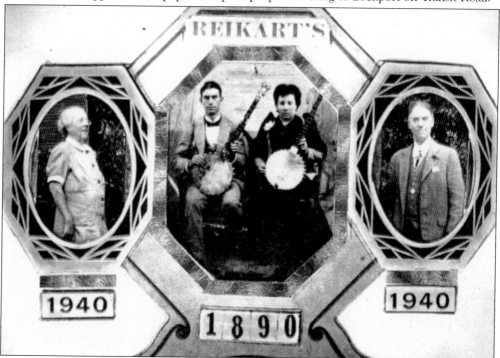

The Reikarts of Swormville. Frank and Dolly Reikart lightened up life in Swormville at the turn of the century. Retired vaudevillians, they ran a series of businesses including a popular ice-cream parlor. Frank Reikart was a music teacher, photographer, and barber. His unique little shop now stands on the grounds of the Amherst Museum.

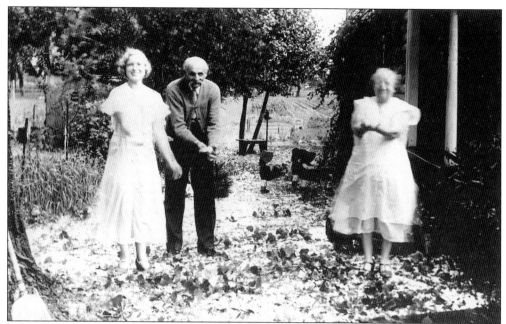

A Rare Hailstorm. A rare hailstorm hit Swormville in 1934. Shown here are Mary Reikart (left), John Herdegen, and Dolly Reikart, marveling at—and obviously enjoying—the unusual happening that befell their community.

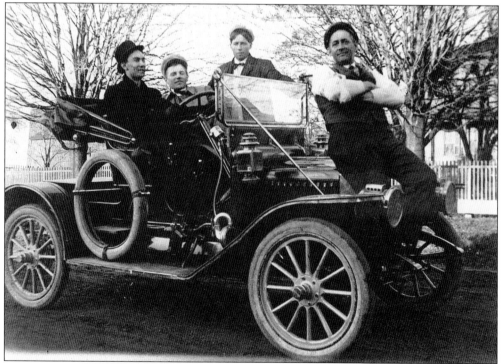

An Early Automobile. Frank Reikart took this picture of men in an early automobile from the front of his barbershop in Swormville. Many early automobile owners traveled on Transit Road en route to Lockport or just for an enjoyable Sunday ride.

46

Four

TRANSPORTATION AND BUSINESS

The agricultural economy of Amherst in the 19th and 20th centuries needed the support of a strong transportation and business base for it to succeed. Primitive mud and then wooden plank roads gave way to macadam thoroughfares as the 19th century progressed. Although many of these routes were privately owned toll roads, they were much more comfortable for those who used them. Transportation continued to advance as stagecoaches were replaced with trolleys and commuter trains, making it possible for people working in the center of main cities to live farther from their jobs. Major railroads were a boon to agriculture, facilitating shipment of products such as flour and produce to markets near and far. They also provided easy access to farm equipment and other farm necessities. Later, these railroads brought in the building materials to foster the housing boom that the town experienced beginning in the 1920s.

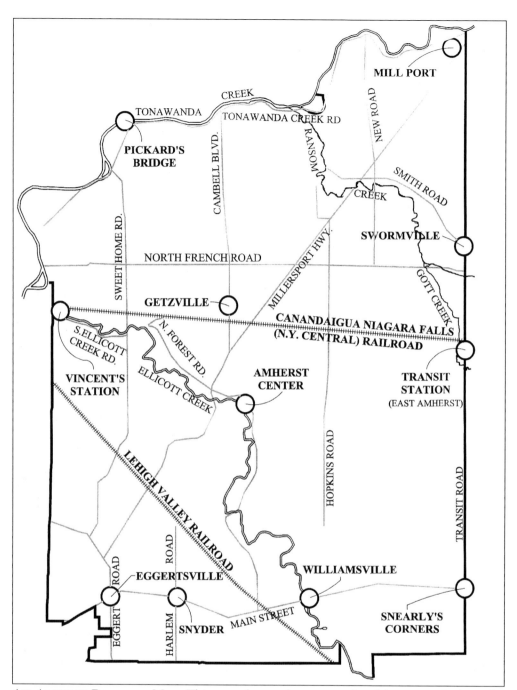

AN AMHERST RAILROAD MAP. This map shows where two railroad lines were built in the 19th century. First came the Canandaigua and Niagara Falls Railroad, later a division of the New York Central Railroad. It opened in the mid-1850s and was popularly called the Peanut Line because a New York Central executive allegedly referred to it as "a peanut of a line." It ran east to west through the central part of Amherst. The second line, built in the 1890s, was the Lehigh Valley Railroad, which ran southeast to northwest from Depew to Williamsville and then on to Tonawanda and Niagara Falls.

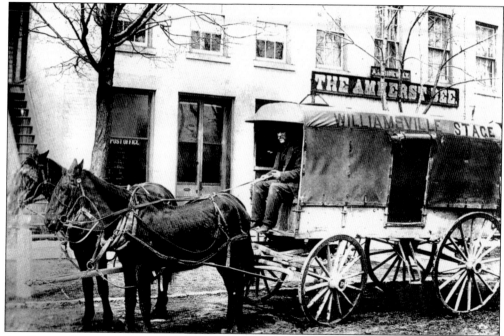

AN EARLY STAGE. Stagecoaches and freight wagons, frequently canvas-covered Conestoga wagons pulled by five or seven horses, served as the first forms of conveyance over the Buffalo Road (Main Street) through Amherst, traveling between Albany and Buffalo. Originally a dirt road, the Buffalo Road was soon improved to become a log, or corduroy, road and then a plank road to avoid problems posed by dirt roads, especially during the rainy season. Later came the use of macadam pavement, composed of packed small broken stone, which was easier to maintain and allowed for a smoother ride. Shown here is an early stagecoach parked in front of the offices of the *Amherst Bee*.

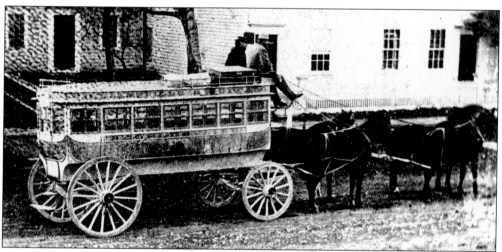

THE STAGECOACH LINE. By 1860, stagecoaches were drawn by four horses and were improved to become imposing vehicles with glass windows to protect travelers from the elements. By 1866, the Buffalo, Williamsville, and Clarence Omnibus line operated coaches leaving Williamsville at 8:30 a.m. and 5:00 p.m. and leaving Buffalo at 3:00 p.m. for the return trip to Williamsville.

THE GETZVILLE TOLLGATE. The Buffalo and Williamsville Macadam Company incorporated in 1836 to build a toll road along Main Street, connecting the two settlements. Stockholders included prominent Amherst residents such as members of the Hopkins, Eggert, and Hutchinson families. Tollgates were located every nine miles, with one near Getzville Road. Tolls posted included rates for vehicles and bicycles. Even farmers driving livestock to market were charged on a per-head basis. Custodians of the Getzville tollgate were members of the Fry family, including Charles and Frank Fry, shown here with their mother.

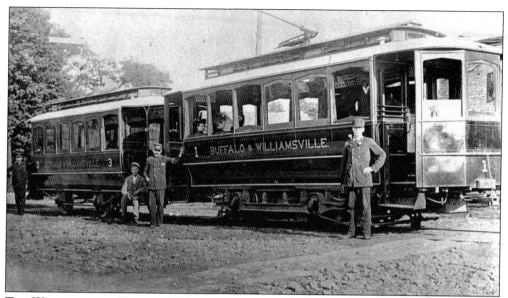

THE WILLIAMSVILLE TROLLEY. When, in 1891, the Buffalo commuter train and trolley system reached the southwest border of town, pressure grew to replace the stage line with a trolley system through Amherst, connecting with the Buffalo system at what is now Main Street and Bailey Avenue. A group of businessmen from both Amherst and Buffalo incorporated the Buffalo and Williamsville Railway Company and received a franchise grant from the Amherst town board. The "Toonerville Trolley" opened for business on April 5, 1893, amid great celebration. With a small depot at the city-town line, the trolley initially traveled only four and a half miles to the east end of village of Williamsville. The line, however, was eventually extended another three miles to the east end of the town at Transit Road and Main Street.

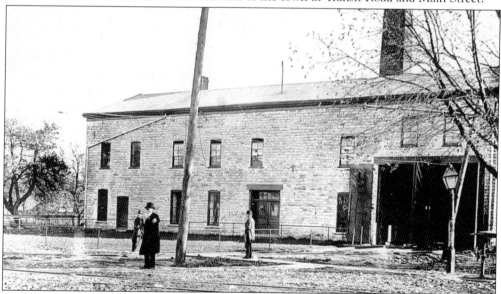

THE TROLLEY POWERHOUSE. Constructed in 1850 in central Williamsville for other purposes, this building was converted into a powerhouse and carbarn with the coming of the trolley. The first superintendent of the company was businessman and philanthropist John Blocher (foreground).

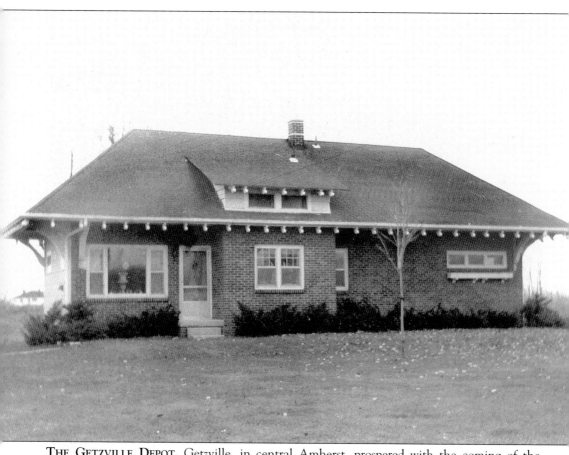

THE GETZVILLE DEPOT. Getzville, in central Amherst, prospered with the coming of the Canandaigua and Niagara Falls Railroad, as did other hamlets that sprang up along the line like Transit Station on the east and Vincent's Corners on the northwest. Important businesses inevitably located near the railroad line. The Getzville Depot was built near the Getz Brothers milling and lumber enterprises. When the railroad ended passenger service (1932) and freight service (1952), the depot was moved and converted into a residence.

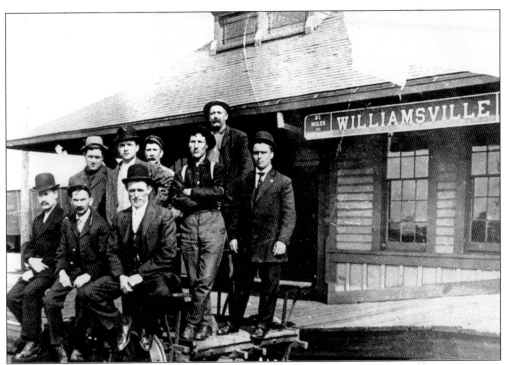

THE LEHIGH VALLEY DEPOT. The Lehigh Valley Railroad Depot opened in 1896 on South Long Street in Williamsville. At the depot, passengers could buy tickets for special excursions to Niagara Falls, Washington, Philadelphia, Rochester, Atlantic City, and Toronto. Passenger service ended in 1940.

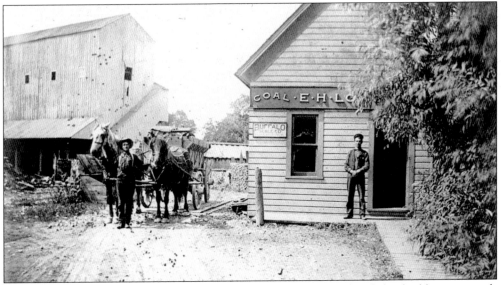

RAILROAD FREIGHT. The Lehigh Valley Railroad carried much of the building materials and coal needed for an expanding town of Amherst. The E. H. Long Coal Company located its facilities at the Lehigh Valley track crossing on Main Street to allow easy distribution to customers. Much of the lumber used to build the homes when Amherst began to suburbanize came via the Lehigh Valley line. The railroad ceased freight operations in 1976.

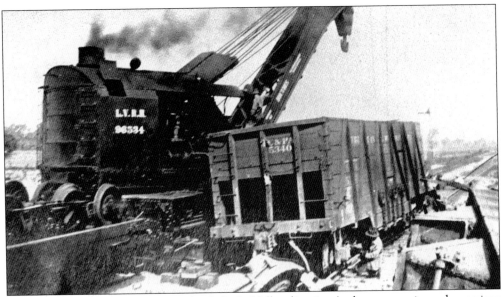

A RAILROAD WRECK. In 1926, the Lehigh Valley line in Amherst experienced a serious derailment of railroad cars at Snyder, causing much excitement and concern to local residents. This was a rare occasion along any of the railroad lines in the town.

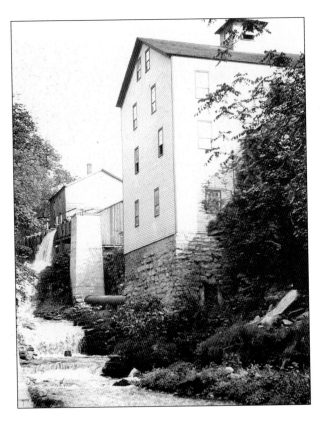

THE WILLIAMSVILLE WATER MILL. Milling was a major enterprise in rural Amherst, with many mills dotting the town landscape. Leading the way was the Williamsville Water Mill at the falls in the Glen, where other industries had been established to serve local villagers and farmers. There were, however, other major mills located elsewhere along Ellicott Creek.

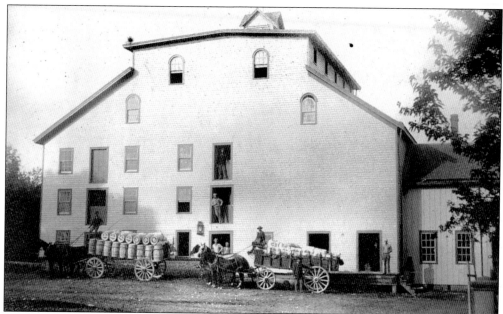

THE DODGE MILL. In 1864, Jonathan Wayne Dodge of Buffalo purchased a mill on the high east bank of Ellicott Creek and did a major upgrading, making it a roller mill that came to be called the Dodge Mill. His sons Henry and Leonard Dodge took over operation of the very profitable business. The mill produced 150 barrels a day and 3,000 barrels a year. Henry Dodge, who chaired the village fire company, perished while fighting a spectacular 1894 blaze that engulfed the imposing mill.

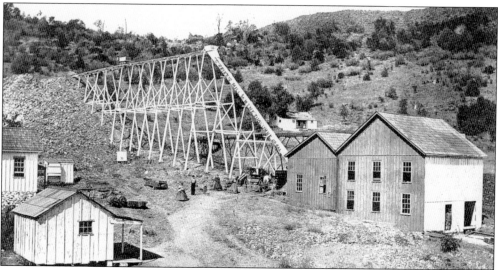

THE REIST MILL. John Reist, who came to Amherst in 1808, and his brother-in-law Abraham Long built a flour mill in 1821 that spanned their adjoining properties. Incorporated as the Reist Milling Company, the flour mill became the center of family businesses that included a hemp mill and a sawmill. The first load of wheat shipped from the west over the Great Lakes was hauled to the Reist Mill from Buffalo to be ground into flour. Reist business interests eventually included investments in lake and Erie Canal shipping, which often carried wheat over the Great Lakes to the Reist Mill and milled flour over the Erie Canal to New York City.

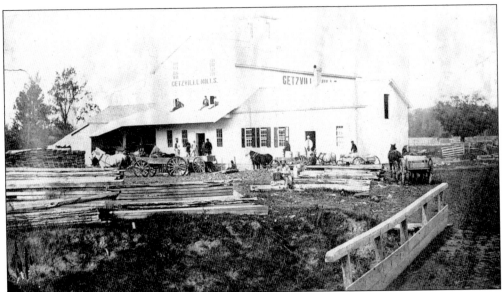

THE GETZVILLE MILLS. The Getzville Mills, located next to the Canandaigua and Niagara Falls rail line, included gristmills, sawmills, and a cider mill. Located at what is now the intersection of Dodge Road and Campbell Boulevard, they made Getzville a thriving center, serving both local residents and nearby farmers.

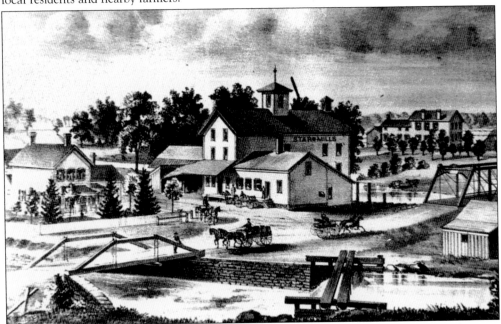

THE WOLF MILL. Amherst native George Wolf ran a farm and farm implements business and, in 1877, purchased a milling enterprise on what is now Millersport Highway, just south of North Forest Road in the area called Skinnerville. Originating as early as 1806, the milling enterprise under his ownership included a sawmill, a gristmill, and a flour mill. Loads of his Star brand flour were shipped to Buffalo daily. During the winter months, Wolf employed up to 16 men who sawed logs in his sawmill. Fortunately, when the creek waters were low, he used gas from nearby wells to drive an engine to power his mills.

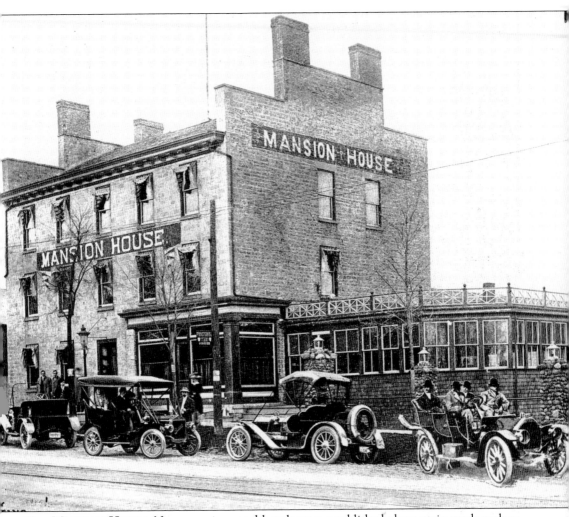

THE MANSION HOUSE. Numerous inns and hotels were established along main roads such as Main Street and Transit Road in Amherst. Perhaps the most prestigious and long-lasting was the Mansion House, on the south side of Main Street just east of Cayuga Road. Built in 1835, it stood for 120 years. Businessman Oziel Smith, who owned the Williams mills properties for a time, had it constructed; it became the most fashionable hotel in Williamsville, attracting patrons from Buffalo and other nearby communities. Built of local limestone, it had an elegant ballroom, 2 bars, and 12 fireplaces.

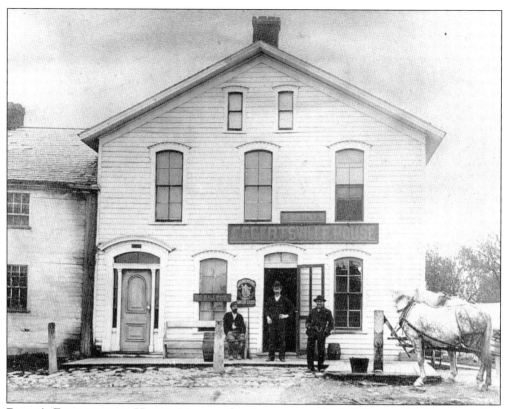

BERKE'S EGGERTSVILLE HOUSE. More modest in scope was Berke's Eggertsville House, an inn and tavern on the southeast corner of Main Street and Eggert Road. It may have been built as early as 1816 and expanded in 1832. Seven years later, it came into the hands of Frenchman Nicholas Chassin and after his death went to his son-in-law John Berke, shown here in the doorway *c.* 1875. Before the end of the century, Berke sold the property to Michael Sauter, and for many years the Sauter family operated the Grunt and Squeal grocery and butcher shop here.

HIRSCH'S PALACE HOTEL. In 1891, John Hirsch built an elegant residence in the hamlet of Transit Corners at the Main Street–Transit Road intersection. Soon converted into a hotel and restaurant, it became very popular with the carriage trade, affluent customers who were attracted by its reputation for an elegant atmosphere and fine food. Added runs of the trolley were arranged to bring guests to special events at the hostelry, and in 1909, the Automobile Club of Buffalo held a corn roast and clambake on its grounds. The hotel burned it to the ground in 1938.

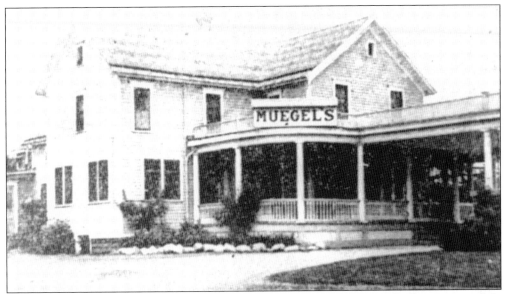

MUEGEL'S HOTEL. Muegel's Hotel, at Transit and Muegel Roads, attracted affluent automobile owners in the early 1900s. They rendezvoused there to enjoy afternoon tea and fine food. They could also enjoy the pavilion and lawn tents on the grounds for summer picnics. Tennis courts and fishing in a nearby creek were available, as well.

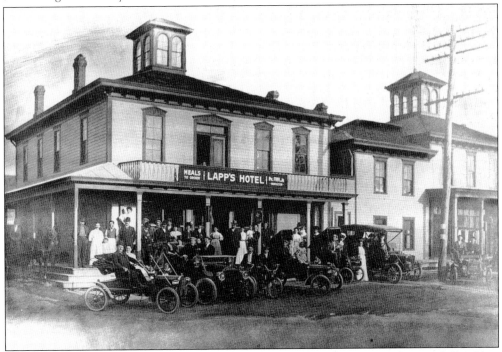

LAPP'S HOTEL. In the early 1890s, Philip Fink advertised his Lapp's Hotel, one of the oldest buildings in Swormville, as providing "special service to automobile and sleigh ride parties." It was at times a store, dance hall, insurance office, and post office. The large upstairs hall hosted performances of plays by nearby St. Mary's School pupils until a new school building was constructed in 1907.

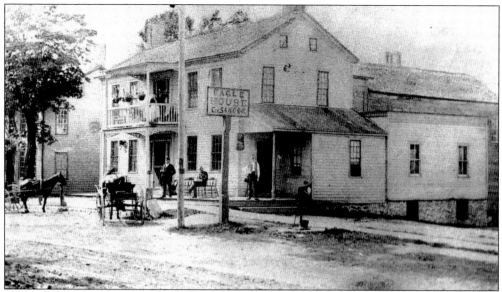

THE EAGLE HOUSE. Entrepreneur Oziel Smith built the Eagle House on the north side of Main Street in Williamsville and opened it for business in 1832. The Eagle House soon served as a major stagecoach stop, as well as the village recreational, social, and political center. Built of local wood and limestone, it had two fieldstone fireplaces, a large bar, and eight guest rooms. Elections were often held here. Some evidence indicates that it may have been a station on the Underground Railroad, which spirited runaway slaves to Canada before the Civil War.

THE FOGELSONGER QUARRY. John Fogelsonger, one of the first Williamsville settlers, acquired land on Main Street at the west end of the village. Here, he first established a cider and then gristmill and, by 1830, opened a limestone quarry. That quarry expanded to 220 acres and for years was a major supplier of limestone in western New York. The Fogelsonger complex included not only business-related structures such as kilns but also homes for the workers and their families. The quarry, later know as the Williamsville Quarry, disappeared in the 1960s with the construction of the thruway (Interstate 90) and Youngmann Highway (Interstate 290) intersection at Main Street.

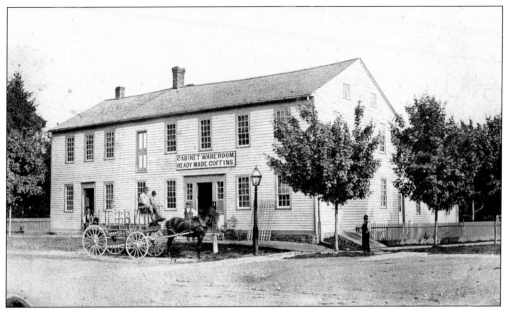

DEMETER WEHRLE. Demeter Wehrle emigrated from Germany in 1848 and soon settled in Williamsville. He bought the old Williamsville Hotel, at Main Street and Cayuga Road, which he converted into a cabinet shop where he made furniture, cabinets, and coffins. Additionally, he served as a mortician and conducted funeral services for local residents. He is shown here standing in front of his shop.

THE BEACH-TUYN FUNERAL HOME. The original Wehrle cabinet shop was replaced in 1888 by a frame structure topped by a cupola. The building still stands today, with some modification, as the Beach-Tuyn Funeral Home. The business continues to involve owners with Wehrle family ties.

61

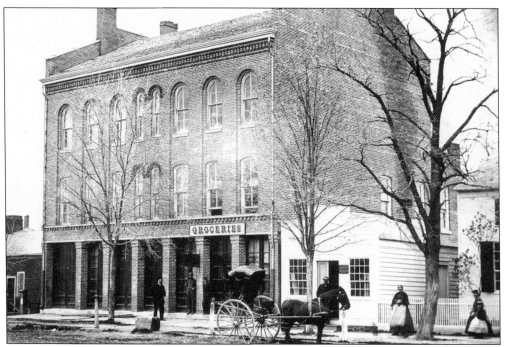

THE RONEKER BUILDING. The Roneker Building, one of Williamsville's most historic buildings, has housed over the years various enterprises such as a school, a grocery store, a tailor shop, and a men's and boys' apparel store. In addition, the law offices of prominent business and political leader Timothy A. Hopkins were located there. The third floor was an entertainment center, in which concerts, plays, and dances were held.

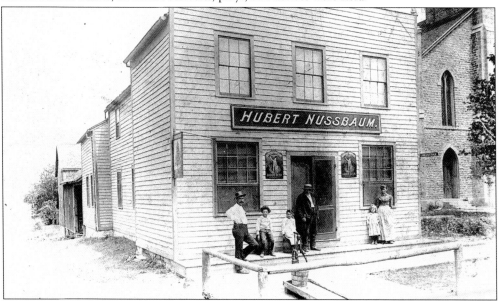

THE NUSSBAUM SALOON AND GROCERY STORE. The Hubert Nussbaum lager beer saloon and grocery store operated at the corner of Main and Grove Streets during the middle of the 19th century. It stood near St. Peter and Paul's Roman Catholic Church, which was being rebuilt and expanded to accommodate its growing congregation.

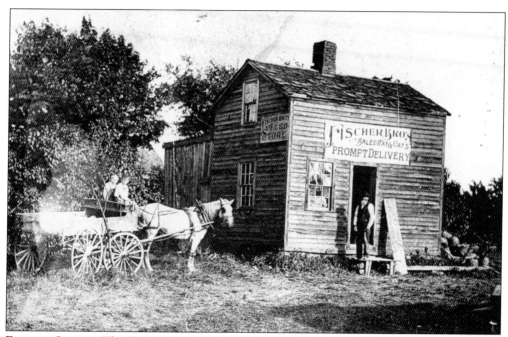

FISCHER GRAINS. The Fischer Brothers Feed Store, on Main Street in Snyder, assured patrons of prompt delivery of hay and oats sold there. The business later expanded into a general merchandise store, with barns and sheds nearby. Shown on the wagon are two Fischer boys, who are under the watchful eye of an unidentified Fischer employee. The business was destroyed in the 1905 Snyder fire.

THE LONG STORE. In 1879, Henry M. Long opened an agricultural implement and general hardware store at the corner of Main Street and North Cayuga Road. He is shown here in the center in front of his store, which he later sold to his son-in-law Milton J. Hoffman. A political and business leader in Williamsville, Hoffman operated not only the agricultural implements business but also a saloon at the store.

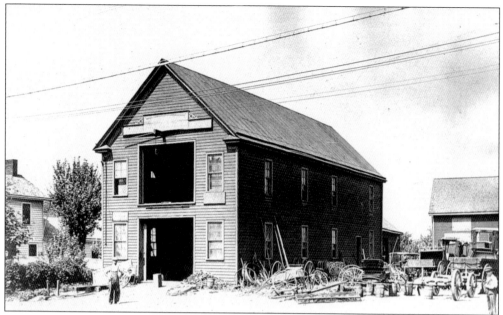

THE HELFTER BUSINESSES. George L. Helfter ran a blacksmith shop and ornamental ironworks in Snyder at the corner of Main Street and Harlem Road. Nearby, he had a wagon works. The disastrous 1905 fire in Snyder began in the loft of his barn and destroyed not only his businesses but also his home.

THE CENTER HOUSE TAVERN. The Center House Tavern, located in the Heim–North Forest Roads intersection area, originated as the first home of German immigrant George Kibler. After Kibler built a stone residence across the street, the house evolved, with various owners and additions, into the Center House Tavern. It became the social center of the tiny hamlet of Amherst Center. Showers, wedding receptions, harvest balls, and Christmas parties were held here. Among those pictured are owner Charles Engel (in the doorway) and Molly Engel (seated with dog at her side) *c.* 1911. The tavern was torn down in the 1970s during the reconstruction of North Forest Road.

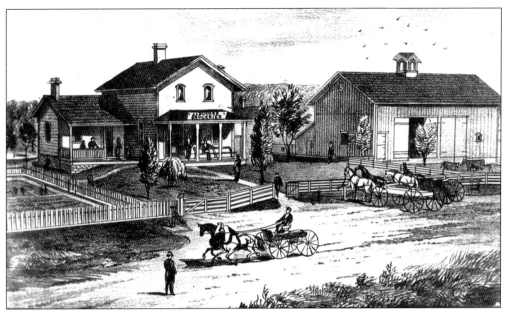

THE BUCHER HOME AND STORE. Joseph L. Bucher's family was one of the earliest families in Getzville. The Buchers owned land on New Home Road (now Campbell Boulevard) north of the Canandaigua and Niagara Falls railroad tracks. Joseph Bucher's residence, dating back to the 1860s, also included a grocery store. A local constable, Bucher was also postmaster from 1887 to 1909, and the post office was located in his store.

KRAMER'S TAVERN. Kramer's Tavern and Store, located on the Erie Canal at the tiny hamlet of Pickard's Bridge, in north central Amherst, is pictured in 1895. Owned by Jacob Kramer, local farmer, businessman, and civic leader, it catered to not only local residents but also passengers on the Erie Canal who stopped here to buy sandwiches and beer, which could be enjoyed on chairs and tables provided by the owner. Kramer's also boarded horses and mules that were used on the towpath of the Erie Canal. Although now empty, the building still stands.

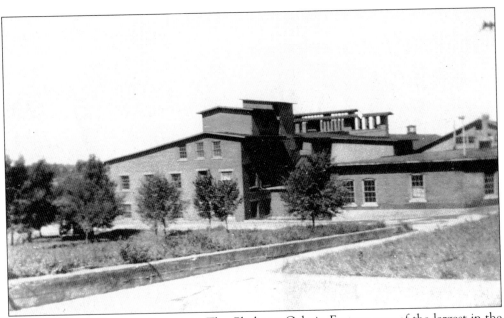

THE CHALMERS GELATIN FACTORY. The Chalmers Gelatin Factory, one of the largest in the nation, was by far Amherst's largest industry. Located on 91 acres with pure spring water and gas wells on Evans Street, its gelatin products were marketed through retail outlets in the East. They were produced for household uses such as jellied salads and meat, as well as ice cream, marshmallows, and candy. During World War I, the factory was converted to assist in producing munitions and photographic supplies needed by the armed forces. It operated until well into the 20th century.

THE AMHERST BEE. The first edition of Adam Rinewalt's weekly *Amherst Bee* came out on March 27, 1879, and featured news, railroad timetables, and Buffalo market quotations for the residents of Amherst and adjoining towns. It covered state, national, and foreign news, as well as topics of interest from area villages and hamlets. The *Bee* included a printing shop, in which both English and German were often spoken because of the large German population in the area.

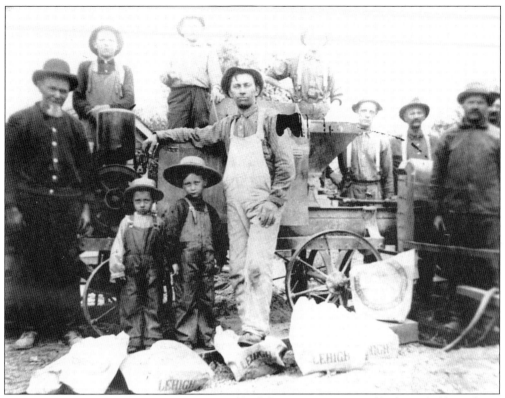

LEISING'S BUSINESS. John Leising's cement block business in Swormville depended heavily on access to the railroad at Transit Station, just south of Swormville. John Leising (center), the local justice of the peace and highway inspector, stands with his workers next to the cement mixers used to make blocks and lay sidewalks.

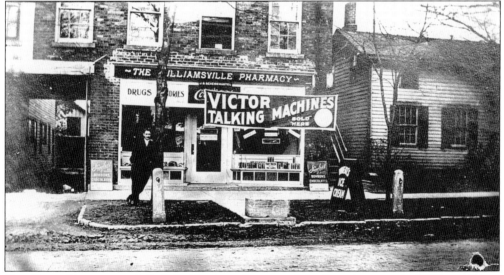

THE FIRST PHARMACY. J. B. Scheidenmantel operated the first pharmacy in Williamsville at the beginning of the 20th century. He is shown here leaning against a tree on Main Street. Take special note of the advertisements for products he sold in his business establishment.

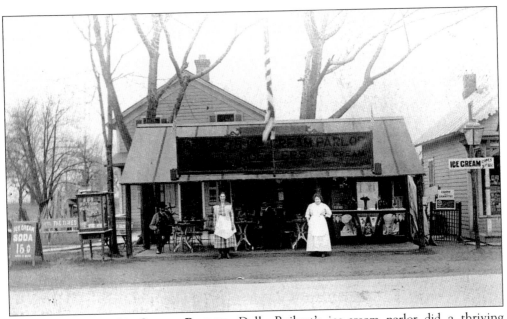

THE SWORMVILLE ICE-CREAM PARLOR. Dolly Reikert's ice-cream parlor did a thriving business, attracting local residents, as well as travelers to Lockport. Others out for a Sunday ride also stopped there. This old-fashioned ice-cream parlor was once featured in Ripley's Believe It or Not.

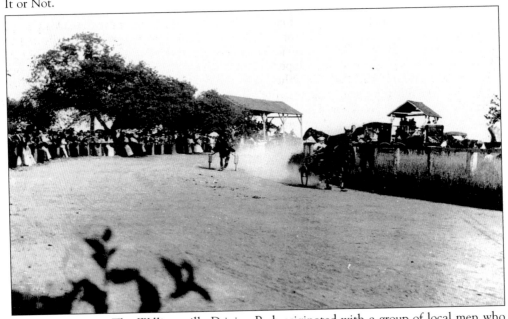

THE RACETRACK. The Williamsville Driving Park originated with a group of local men who enjoyed raising and racing horses. They leased land on Main Street east of Garrison Road and built a track, a dance pavilion, and eventually a hotel-restaurant that evolved into what was called the Little White House. The track hosted Fourth of July celebrations, bicycle races, picnics, and school field days. It attracted throngs of people from as far as Buffalo, who came over the Toonerville Trolley line, which originally stopped at the track before being extended to Transit Road and Main Street.

Five

LEARNING AND RELIGION

Education and religion were very much part of the lives of the people of Amherst from the beginning. Small rural elementary public school districts with one-room schoolhouses were established as the population grew in each part of the town. At the secondary level, the Disciples of Christ Church sponsored a private secondary school, the Williamsville Classical Institute, which drew local students, as well as those from other states. It was turned into a public elementary school and eventually a public high school called the Academy Street School. Parochial schools like those at St. Peter and Paul Church in Williamsville and St. Mary's Church in Swormville also provided elementary school education in Amherst. At the secondary level, a program was developed at the Academy Street School c. 1900 and became the first Williamsville High School. Other high schools followed, like the private Park School (with an elementary program) and Sacred Heart Academy. The new public Amherst Central High School was opened when a new school district was created in the late 1920s. Many of the schools were sponsored by the myriad Amherst churches. Religious diversity was typical in Amherst, with faiths ranging from Mennonite to Catholic to Methodist, Baptist, Disciples of Christ, and Lutheran. More recently, Jewish, Hindu, and Islamic religious institutions were established.

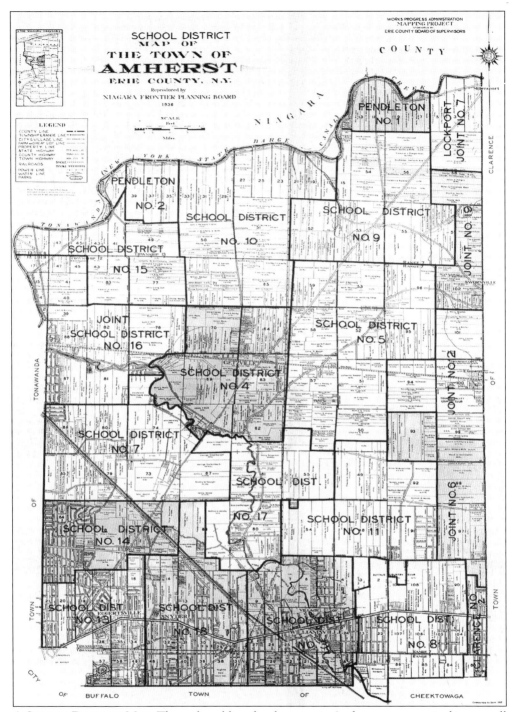

A SCHOOL DISTRICT MAP. The early public school system in Amherst was organized into small districts, as shown above. Each started off with a one-room schoolhouse. The only original one-room schoolhouse still standing at its original location is District No. 17 school, at Maple and North Forest Roads. Several others were moved to the grounds of the Amherst Museum village.

THE STONE SCHOOLHOUSE. The importance of education in Amherst can be seen when, as early as 1812, Caleb Rogers opened a private school at the corner of Main Street and Garrison Road. Public school education began in 1817 with the construction of a school at Main and Grove Streets. That school was moved to 70 Eagle Street for a while. In 1840, however, a one-room stone schoolhouse, shown here, was built at 72 South Cayuga on land donated by Timothy S. Hopkins. Built of stone from local quarries, it continued in use until 1924. The stone school building later became the first Amherst Senior Center and then the first home of the Amherst Museum.

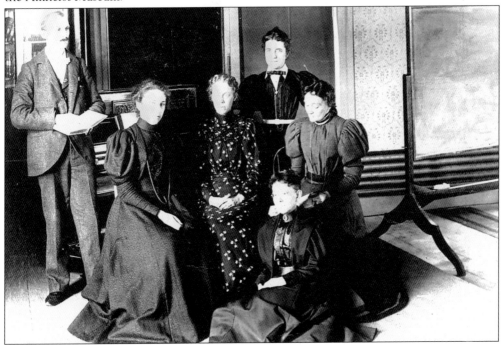

THE PUBLIC SCHOOL FACULTY. The public school faculty in 1898 consisted of, from left to right, D. B. Albert, principal; Bessie Emerson, preceptress; Mabel Woolsey, seventh and eight grades; Minnie Flanagan, fifth and sixth grades; Bertha Spaulding (seated on the floor), first and second grades; and Ella Westland, third and fourth grades.

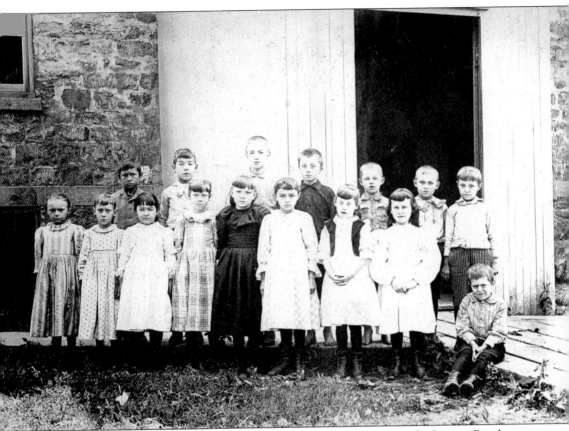

STONE SCHOOLHOUSE PUPILS. The 1840 stone schoolhouse on South Cayuga Road came to be known as Miss Spaulding's School for teacher Bertha Spaulding, who taught there for many decades into the 20th century. Children who attended the school came from some of the leading families in Williamsville, such as the Grove, Seitz, and Klein families. Included in this 1892 photograph is Sue Miller (Young), the third girl from the right. As an adult, she helped found the Williamsville Historical Society, served as town historian, and in 1965, published the first comprehensive history of the town of Amherst.

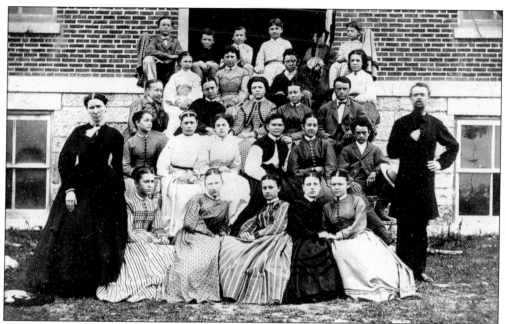

THE GRADUATION OF 1868. The Williamsville Classical Institute, a private secondary school, was the first educational institution in Amherst above the elementary level. Built in 1853 on land acquired from the Hershey family, it was sponsored by the Disciples of Christ Church and attracted boarding and commuter students. The students pictured here were from prominent local families, Canada, Michigan, and the District of Columbia. They followed a three-year course of study that included philosophy, theology, botany, chemistry, languages, and rhetoric. The institute closed in 1869.

ACADEMY STREET SCHOOL PUPILS. The Academy Street School, the former Williamsville Classical Institute, although first rented, was purchased outright in 1892 by Williamsville District No. 3. As this 1880 photograph indicates, it was only an elementary school until the high school division was added c. 1900. Not all Williamsville pupils attended the Academy Street School. It housed pupils from the third grade to the high school. The others continued to attend the stone school schoolhouse on South Cayuga Road.

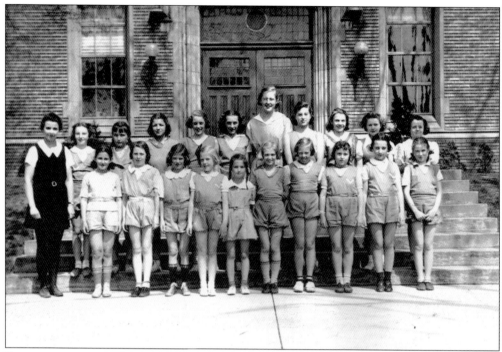

EXTRACURRICULAR ACTIVITIES. Extracurricular activities at the Academy Street School included an elementary school girls' tumbling club (above) and the high school boys' chorus (below). These activities augmented the rigorous course of academic studies that each student was expected to complete.

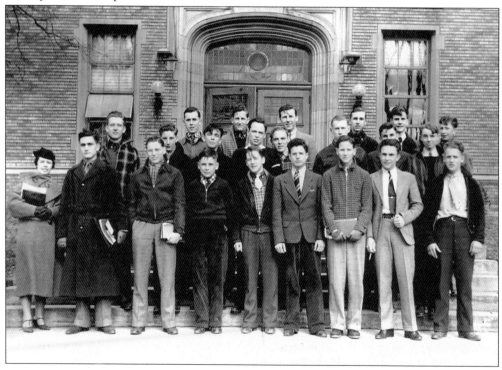

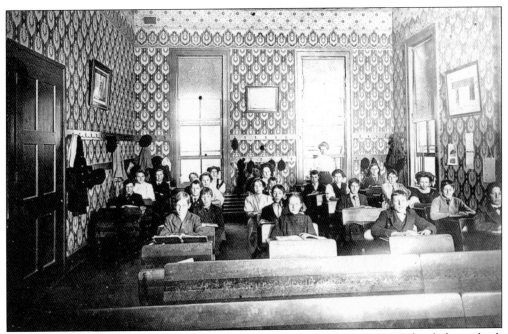

THE ORNATE SCHOOL INTERIOR. The rich interior of the Academy Street School, dating back to the days of the Williamsville Classical Institute, is shown here in a class photograph taken in 1903.

THE SNYDER DISTRICT NO. 18 SCHOOL. Snyder's District No. 18 replaced a structure built in 1867 with a new one at Main Street near Burroughs Drive in 1900 under orders from the New York State Department of Education because of overcrowding. It was first a one-story structure, but a second story was soon added.

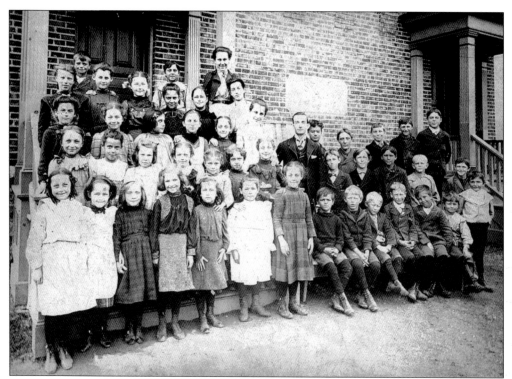

A Snyder School Class Photograph. The school in Snyder's District No. 18 included children of early settlers such as the Fogelsongers, Snyders, Bates, and Fruehaufs. This class photograph was taken in front of the school in the early 20th century.

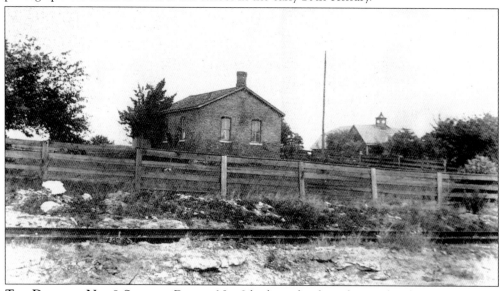

The District No. 8 School. District No. 8 built a school on the north side of Main Street beyond Youngs Road toward Transit Road. It was located on land donated by the Youngs family. The school later had to be expanded with the opening of the Methodist Home for Children nearby and the division of the Lautz estate into a residential community. Added were more classrooms, a library, and additional lavatories.

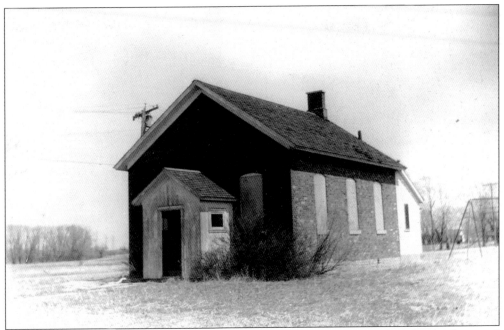

THE DISTRICT NO. 17 SCHOOL. The District No. 17 School still stands today (with several additions) on the southeast corner of Maple and North Forest Roads. Built c. 1860, it later served as a civic meeting center, a dentist's office, and a gift shop. It is the last remaining one-room brick schoolhouse in Amherst and, thus, was the first building designated as a historic landmark by the town of Amherst.

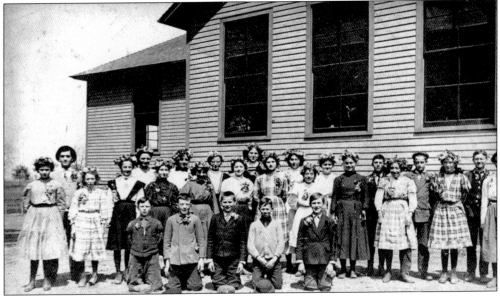

THE GETZVILLE DISTRICT NO. 4 SCHOOL. The District No. 4 School, on Stahl Road in Getzville, replaced an 1878 plank building in 1909. The new structure included a basement for recreation and a library. It opened as a 24- by 40-foot one-room schoolhouse with a stove, one teacher, and 75 pupils. Later, it was partitioned and more teachers were added to handle the increased number of children. This class photograph was taken in 1956.

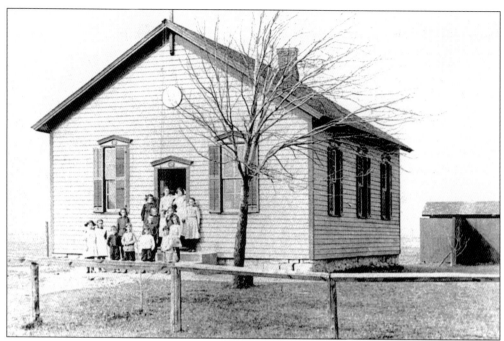

THE EAST AMHERST DISTRICT NO. 9 SCHOOL. The District No. 9 School was built in 1880 at New and Smith Roads to serve the farm families of East Amherst. Up to 35 pupils ranging from 4 to 18 years of age attended the school. The structure now stands on the grounds of the Amherst Museum.

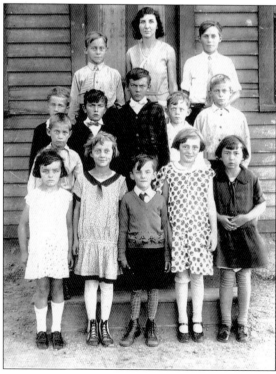

DISTRICT NO. 15 PUPILS. Shown here in the 1920s are pupils in front of the District No. 15 School, with teacher Carol A. Wolgast, herself a graduate of the school. The school closed in 1948 and now stands on the grounds of the Amherst Museum.

THE SWEET HOME ROAD SCHOOL.
District No. 15 built a school on Sweet
Home Road just south of Tonawanda
Creek Road. It opened in 1847 on
land donated by the Wolgast family,
with 22 pupils in attendance. Church
services were held there by the German
Methodists until they built a church
on land also given by the Wolgasts.
Wolgasts served both as ministers of the
church and as teachers in the school.
This recent photograph was taken on
the grounds of the historic village of
the Amherst Museum, where the school
now stands.

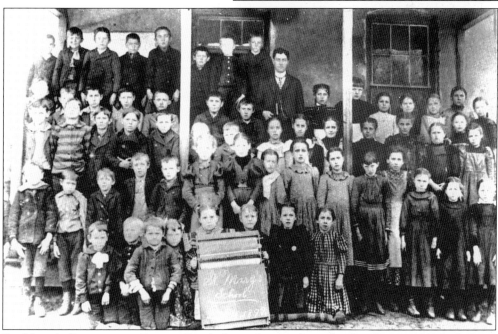

ST. MARY'S SWORMVILLE PUPILS. Pupils shown here with teacher Leo Roy in 1899 had classes
on the first floor of the parish convent. In 1907, a school building was opened to accommodate
an expanding enrollment. Children attending the school came from local families including the
Leisings, Siebolds, Hanels, Spoths, and Kleins. A modern one-story school was built in 1931 to
replace the 1907 building.

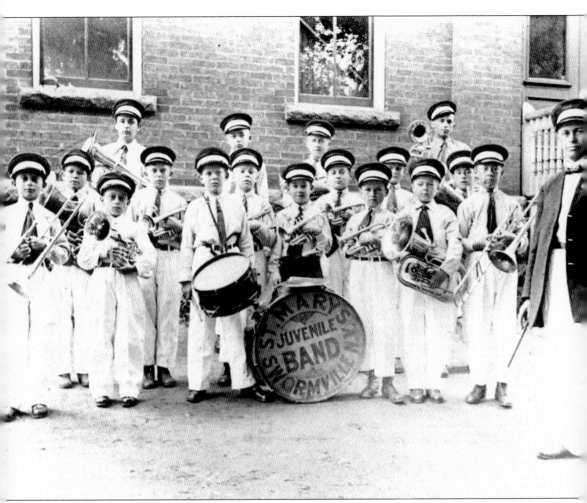

ST. MARY'S SCHOOL JUVENILE BAND. St Mary's School in Swormville was always a very active part of the community. Leaders like businessman John Leising (right) took a prominent role in the school. The Juvenile Band performed at community events. Other activities included plays and field days.

SACRED HEART ACADEMY. The Catholic Sacred Heart Academy, a girl's secondary school, moved its location from downtown Buffalo to Amherst in 1930. Its Georgian-style structure was erected on Main Street near Eggert Road to afford students easy access to the school, particularly by public transportation.

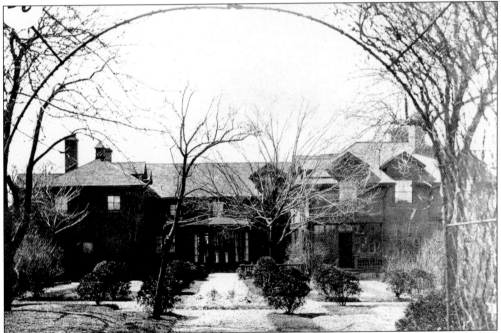

THE PARK SCHOOL. Private education flourished in Amherst with the relocation of the Park School from Buffalo. Founded in 1912 and for many years located at Main Street and Jewett Parkway in Buffalo, it moved in 1922 to the former Chauncey Hamlin estate, on Harlem Road north of Main Street in Snyder. The school included the administration building, shown here, in addition to a historic stone house once owned by the pioneer Schenck family.

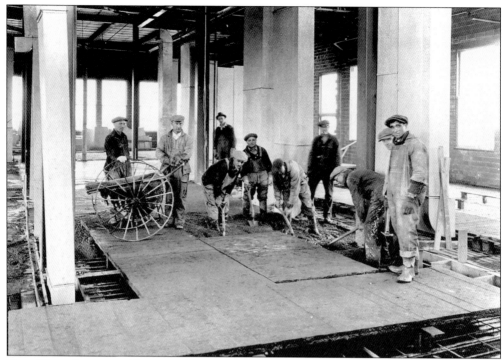

THE NEW AMHERST CENTRAL HIGH SCHOOL. Public secondary education in Amherst received a great boost when the school districts in Eggertsville and Snyder joined together to build Amherst Central High School. Previous high school students from those areas attended either Bennett High School in Buffalo or Williamsville High School. When Buffalo banned suburban enrollment, a campaign began to build a new high school in the area. A 205-acre plot previously dotted with apple orchards and a flour mill was purchased, and construction was begun in 1929. Shown above are men beginning the building of the new Gothic-style stone school and, below, the school nearly completed.

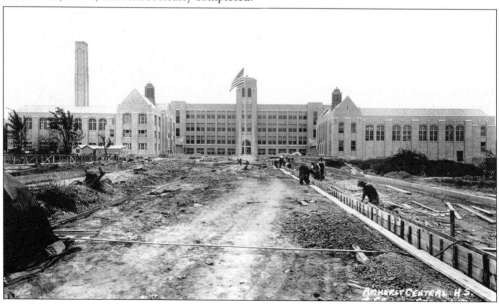

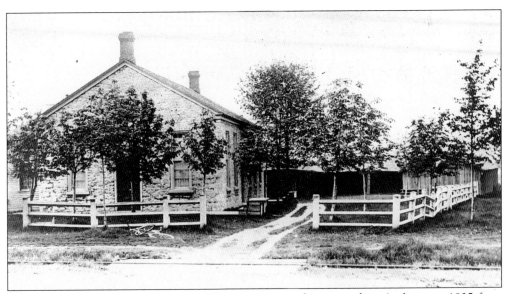

THE MENNONITE MEETING HOUSE. The Mennonites first arrived in Amherst in 1805 from Lancaster, Pennsylvania. Among the early arrivals were John Long and Peter Reist. In 1828, they formed the Reformed Mennonite Church and in 1834 erected the Mennonite Meeting House, shown here, at North Forest Road and Main Street, constructed of stone from the nearby Fogelsonger quarry. The building is now owned by the town of Amherst and used for record storage. It was recently placed on the National Register of Historic Places.

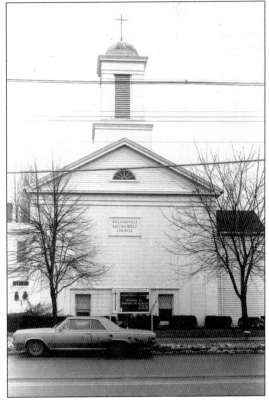

THE WILLIAMSVILLE METHODIST CHURCH. Methodist preachers held services in Williamsville as early as 1807. Two years later, Dr. Glezen Fillmore, cousin to future Pres. Millard Fillmore, arrived and held services in homes, barns, and schoolhouses. The Williamsville Methodist Church was formed in 1834, and its first house of worship was built in 1847 on Main Street on land donated by the Evans family. Although expanded and somewhat altered over the years, it has kept its appearance true to the style of the early frame New England churches.

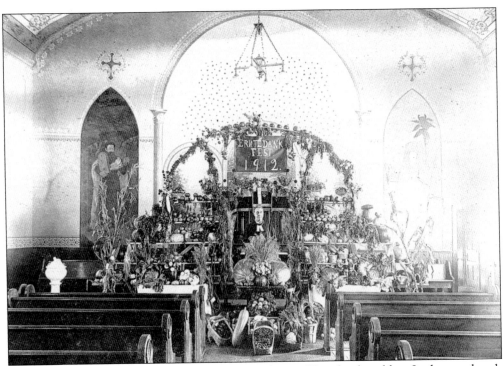

St. Paul's Lutheran Church. St. Paul's Lutheran Church, the oldest Lutheran church in Erie County, was incorporated in 1827 and built on land donated by the Holland Land Company in Eggertsville. People came from Black Rock and Buffalo, as well as Amherst, to worship here. When the Reverend Adolph W. Boettger became pastor, the church name was changed to St. Paul's Evangelical Lutheran Church. A new church, erected in 1874, burned five years later, along with its parsonage and barns. Another church was built in 1879–1880. Shown here is longtime pastor Rev. Ernest C. Burck conducting a harvest thanksgiving service in 1912.

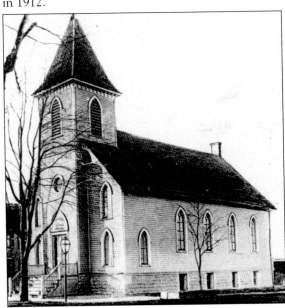

St. Paul's Mission Church. By 1870, the leaders of St. Paul's Evangelical Lutheran Church in Eggertsville saw the need for a mission church in Williamsville. Thus, they purchased the old Christian Church building, at Eagle and North Ellicott Streets. A single minister served both churches from 1870 to 1885. In 1885, the Williamsville congregation called its own pastor and built him a parsonage. By 1900, the old building, shown here, was replaced by a new Greek Revival edifice.

THE WILLIAMSVILLE BAPTIST CHURCH. The Williamsville Baptist Church held its first services in 1826 in a schoolhouse in Bowmansville, which was then part of Amherst. When their membership grew, the Baptists erected their own two-story house of worship with a bell tower at 94 South Cayuga Road. The church was later sold and converted into a residence by local businessman and civic leader Howard Britting.

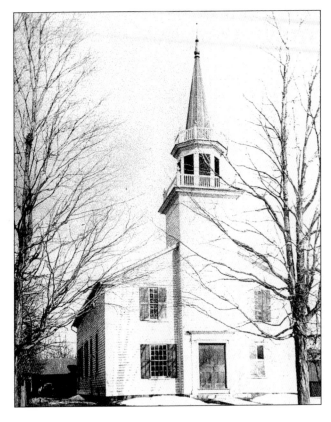

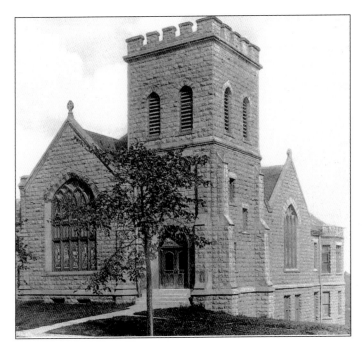

THE STONE BAPTIST CHURCH. The members of the Williamsville Baptist Church built a new edifice in 1903–1904 at the corner of Main and Spring Streets. The church was renamed the Randall Baptist Church in memory of Helen Randall, a generous church benefactor. The daughter of businessman John Hutchinson, she was the wife of Rev. William H. Randall, a minister at the Baptist church for many years who served in the Civil War. That church was later replaced by a new church farther out Main Street beyond Youngs Road.

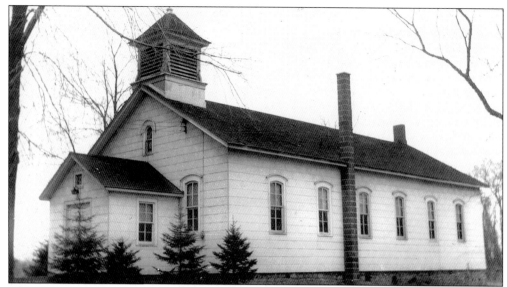

THE LITTLE WHITE CHURCH. The Genesee and French Evangelical Society built the Little White Church on Skinnerville Road in 1879–1880. It was built on a land donation from the Muck family and with other donations from area families such as the Wolfs and the Stahls. A cemetery nearby became the resting place of members of prominent Amherst families. Designated a nondenominational church, it never had an assigned minister. The Lutheran Ladies Aid Society maintained and upgraded it for many years. Now on the State University of Buffalo campus, it has served as the chapel and meeting place for the university's Catholic Newman Club.

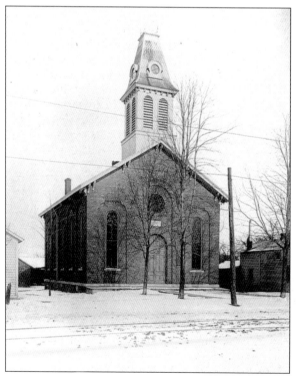

THE CHRISTIAN CHURCH. A group called the Disciples of Christ passed through Williamsville in 1834, baptizing eight people including members of the Hershey and Witmer families. Calling themselves the Christian Church, they built their first meetinghouse at Eagle and North Ellicott Streets. New converts were baptized by immersion in nearby Ellicott Creek. A new church was later built on Main Street, east of Mill Street, and the old church was sold in 1870. The new church, shown here, is now owned by the village of Williamsville and serves as the home of the Williamsville Historical Society.

MISSIONARY JOHN NEUMANN. Because many German Catholics settled in western New York, a German-speaking missionary, John Neumann, was sent to minister to their needs. He resided first in Williamsville, although his parish encompassed much of western New York. While residing in western New York from 1836 to 1840, first at Williamsville, and then at North Bush in Tonawanda, he founded many parishes and schools, from Niagara Falls on the north to Java on the south. He left in 1840 to join the Redemptorist Order and eventually became bishop of Philadelphia. His life of spiritual and temporal accomplishments was recognized in 1977 when he was declared a saint by the Roman Catholic Church.

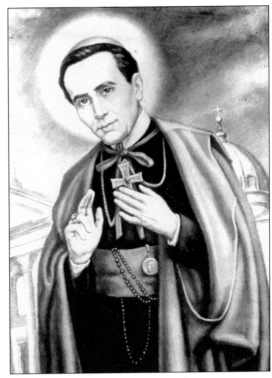

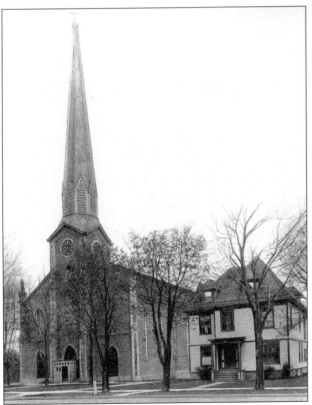

ST. PETER AND PAUL CATHOLIC CHURCH. Catholics in Williamsville organized themselves into a parish even before the arrival of John Neumann. They were served by priests coming out from Buffalo's first parish, St. Louis' Church, located at Main and Edward Streets. The new Williamsville parish, called St. Peter and Paul parish, was completed while Neumann was in residence. He began a school in 1837 in which he taught some classes. The growing congregation purchased more land and, in 1863, laid the cornerstone for a new edifice to be erected from stone taken from nearby quarries. The church was not completed until 1866 due to delays occasioned by the Civil War.

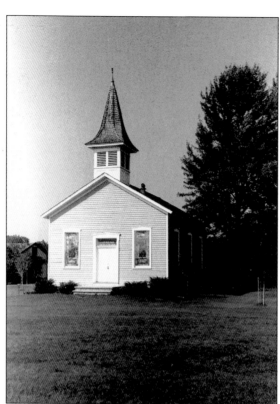

THE TRINITY EVANGELICAL LUTHERAN CHURCH. The Trinity Evangelical Lutheran Church was built in 1854 on Transit at Muegel Roads. It served as a social, as well as religious, center for German-speaking citizens of the hamlet of Transit Station. When the congregation elected to move south along Transit Road to larger quarters, the church was moved to the grounds of the Amherst Museum, where it still serves occasionally as a chapel for small weddings.

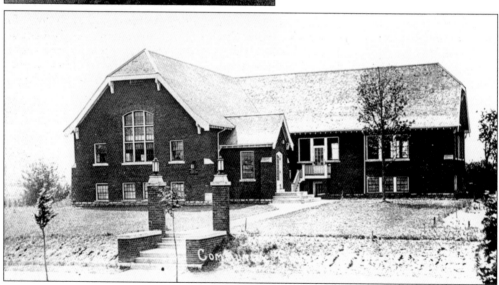

THE AMHERST COMMUNITY CHURCH. The Amherst Community Church led a movement toward interdenominational churches in 1915. Many prominent business and civic leaders from Amherst and Buffalo who built their suburban residences in southwest Amherst were instrumental in founding the church. They were drawn from the Baptist, Methodist, Presbyterian, Lutheran, and Episcopalian communities, among others. The land was donated by the Suor brothers, Amherst developers in the Snyder area. Similar churches were formed in western New York, following the example of the Amherst Community Church.

Six

SUBURBANIZATION

With the dawn of the 20th century, profound changes transformed what had been a mainly rural Amherst with a population of several thousand inhabitants. Located out Main Street next to Buffalo, where the population eventually reached over 500,000 people, the town of Amherst felt the impact of such changes, as more rapid methods of travel allowed people to live a distance from their workplaces. Since Main Street led right into the center of Buffalo, access to Amherst was easy, as trolley lines and commuter trains came into vogue. Large estates of wealthy Buffalo entrepreneurs wishing to escape the urban hustle and bustle first dotted the landscape of southwestern Amherst. Then came residential subdivisions along Main Street for citizens of affluent and modest means who wished to live in the environment of suburbia with its clean air and space. Thus, Amherst changed from a rural community to a residential suburb, first along Main Street and then all over the town. That pattern persists to this day, even though available lands are scarcer and controversies about overbuilding have slowed the pace.

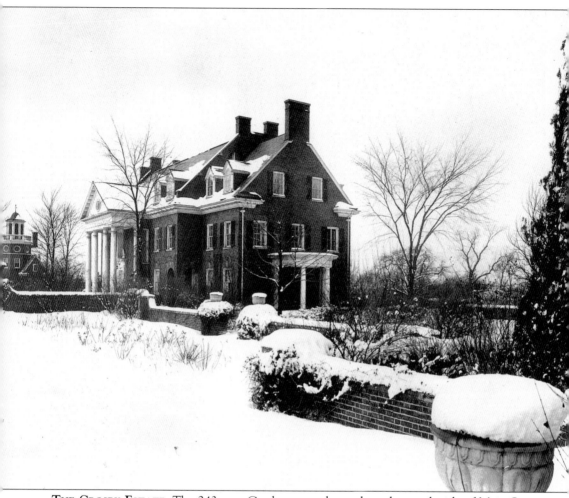

THE CROSBY ESTATE. The 243-acre Crosby estate, located on the north side of Main Street, ran from Bailey Avenue to Eggert Road. Shown here is the Crosby mansion. Owned by business tycoon William H. Crosby, it was one of the first large estates built by prosperous businessmen from Buffalo in the southwest corner of Amherst in the areas of Eggertsville and Snyder at the beginning of the 20th century. Crosby, originally a Congregationalist, joined other business leaders of various denominations to help found the Amherst Community Church. The estate was eventually the site of one of the first large suburban subdivisions erected in Amherst.

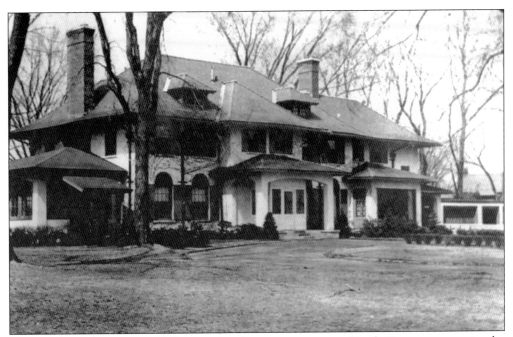

A PRAIRIE-STYLE MANSION. Engineer and paving contractor Frank Bapst, a power in the Democratic Party, developed a six-acre estate south of Main Street off Eggert Road. Here, he built a Frank Lloyd Wright–style mansion, a garage, and a caretaker apartment.

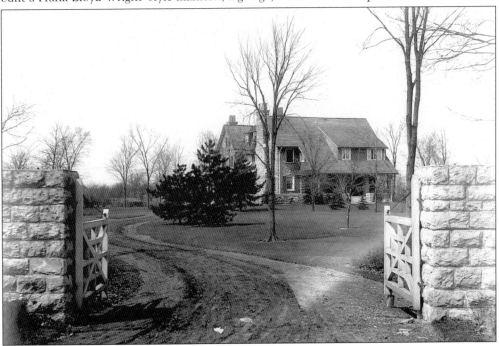

THE HEDSTROM ESTATE. Arthur E. Hedstrom, civic leader and owner of a major Buffalo coal company, had a 43-acre estate on the west side of Getzville Road, stretching from Main Street to Sheridan Drive. In 1904, he built his impressive residence near Main Street, along with a row of caretaker cottages, a stable, and a pool and pool house.

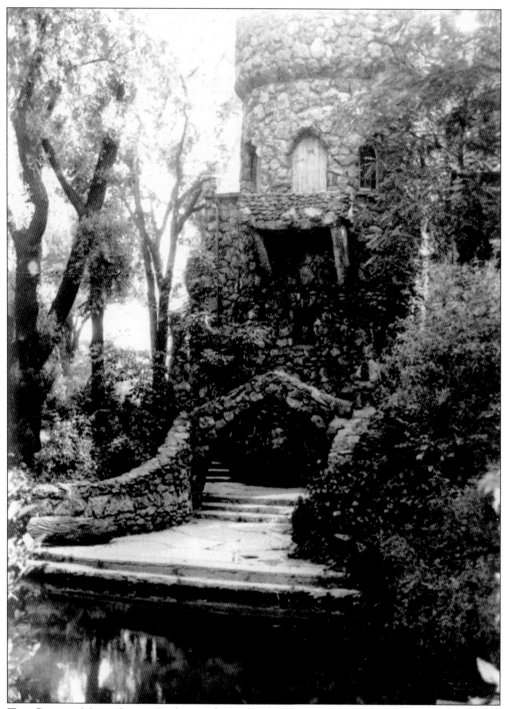

THE CASTLE. Mason Ignatz Oechsner planned to build a stone medieval castle, like one in his German home village, on an island in Ellicott Creek south of Main Street. Construction on the 25-year project began in 1917, using fossil rock from nearby town of Holland. Included in the project were a main building, a gatehouse, a tower, and a coach house. Sadly, Oechsner never lived in the castle because he died before the project was finished.

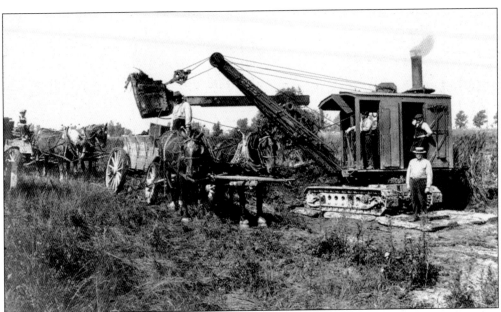

CLEVELAND PARK TERRACE. Estates along Main Street in Eggertsville and Snyder gave way to large-scale suburban residential developments in the 1920s. Buffalo developers financed the construction of the 200-plus-acre Cleveland Park Terrace. Beginning in 1926, they divided up the old Crosby estate, north of Main Street between Bailey Avenue and Eggert Road, and built 1,300 modest to elegant homes on eight miles of concrete streets with sewer lines and utilities already installed.

THE BELINSON RESIDENCE. The first home constructed in Cleveland Park Terrace was the residence of John Belinson, a major builder in the subdivision. He became an active leader in town affairs, as well as in the business community, often reflecting the views and interests of the growing number of suburbanites in Amherst.

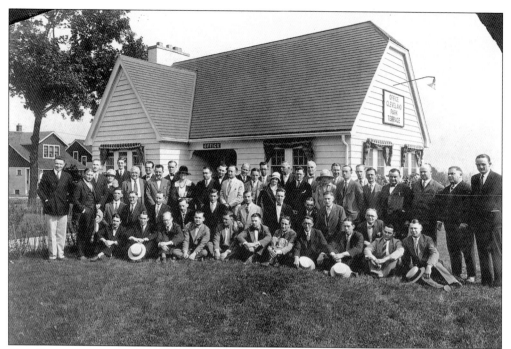

THE SALES STAFF. The sales office of Cleveland Park Terrace was built at Main Street and Bailey Avenue to house a large sales and marketing staff. That staff, shown here, included a number of pioneer women realtors.

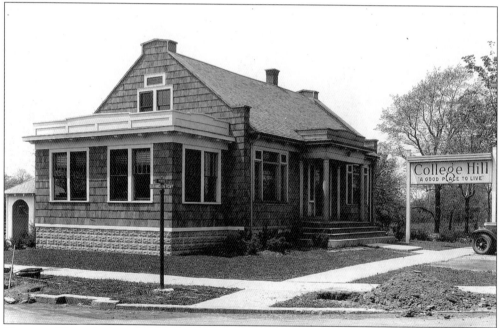

COLLEGE HILL. Amherst native realtors Arthur and William Suor bought the 99-acre Kabel farm and put in macadam streets for a planned subdivision that they named College Hill. The development was located south of Main Street and west of Harlem Road, with its main street, Washington Highway. The modest sales office reflected the nature of the subdivision.

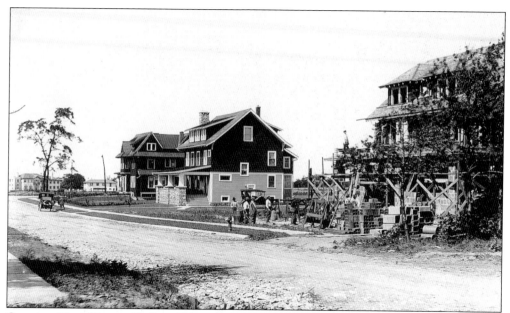

COLLEGE HILL HOMES. College Hill included many two-story, four-bedroom homes with a den and a bathroom on each floor. They were comfortable residences with amenities that appealed to new owners.

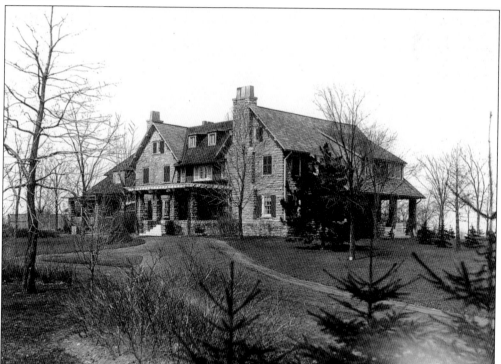

COLLEGE HILL TERRACE. The Suors had expanded their enterprises by 1923 with College Hill Terrace on the old Witmer farm, which was subdivided into 331 lots. It was more upscale than the original College Hill development, with increased lot sizes, upgraded landscaping, and more home designs from which to choose.

AUDUBON TERRACE. Charles Burkhardt developed the Audubon Terrace subdivision, located off Main Street east of Harlem Road in Snyder. Lots varied in size from 50 to 90 feet in width and 160 to 300 feet in depth. Available were brick and frame homes built by Burkhardt and other contractors. Homes were of varied styles including Bungalow, Prairie, Colonial Revival, and Tudor. Both south and north of Main Street, a parklike setting was carefully planned with attractive landscaping and winding streets. Streets were often named after naturalists like Luther Burbank and Charles Darwin. The sales office (pictured) was located at Main Street and Darwin Drive.

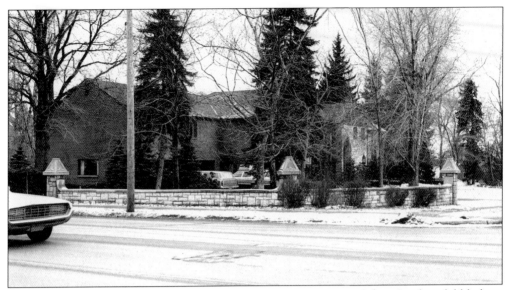

THE HOLLYWOOD SUBDIVISION. Department store tycoon John Sattler dabbled in Amherst's suburban development with his Hollywood subdivision. Shown here is a home in that subdivision, at the corner of Ivyhurst Road and Main Street. Note the stone wall "street furniture" used here and all along Main Street in Eggertsville and Snyder to give entrances to the developments the appearance of entrances to the large estates that once dotted the landscape.

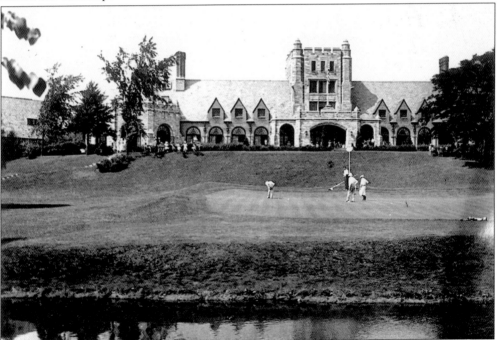

THE PARK COUNTRY CLUB. The Park Country Club relocated from Buffalo to Amherst in 1928, following the movement of its affluent members to the suburbs. The new golf course, with its imposing Tudor-Gothic stone clubhouse, was built along Sheridan Drive on what had been the 140-acre Klopp farm.

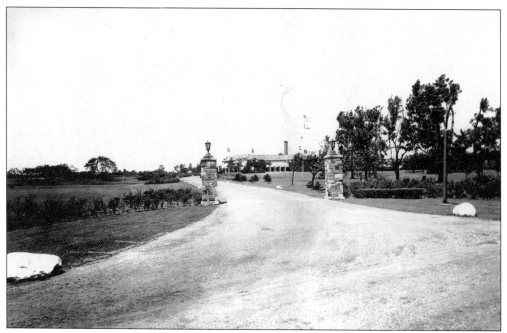

THE TRANSIT VALLEY COUNTRY CLUB. A new country club sprang up in Amherst in 1930 along Transit Road on lands that had been owned by families such as the Ayers and Kleins. The golf course was professionally designed, and the clubhouse was built in the Spanish style, with stucco walls and arched windows.

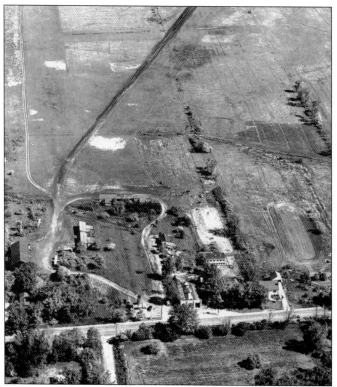

PRIVATE AIRPORTS. Private airports were part of the suburban scene in Amherst as late as the 1950s. Shown here in 1954 is the Sheridan Airport, north of Sheridan Drive and west of Transit Road, used by privately owned planes.

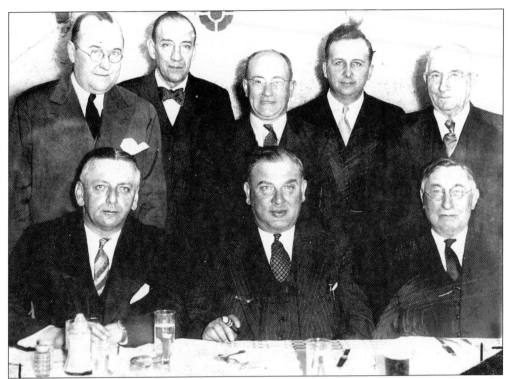

THE AMHERST BUSINESSMEN'S ASSOCIATION. The Amherst Businessmen's Association in the 1920s reflected the suburbanization of the town in its membership. It included longtime town residents like Joseph Sauter (back left) and Fred Muck (back center), as well as newcomers like John Belinson (front center) and Fred Onetto (back, second from left).

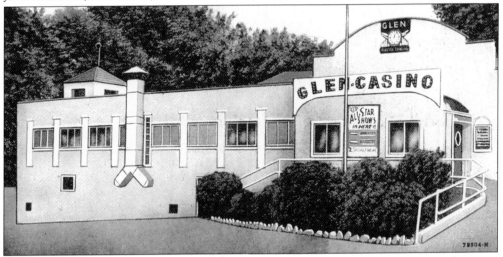

THE GLEN CASINO. One of the major attractions in Amherst for many years was showman Harry Altman's Glen Amusement Park and Casino. Thousands of western New Yorkers brought their children to enjoy the amusement park, and thousands of adults came to the casino, which seated 1,500. The casino had a national reputation; noted entertainers like Sammy Davis Jr., Joey Bishop, Lenny Page, and Bobby Darin got their starts here and frequently returned to perform.

THE CITY ICE COMPANY. The Glen Park facility was City Ice's biggest single customer, to the benefit of founders William Wolf and Charles Sugg. Located on Main Street near Los Robles in Williamsville, City Ice's three trucks moved around Amherst supplying homes and restaurants in days before electric refrigerators became common. Also available was an automated ice machine that provided blocks of ice and, later, bags of crushed ice, to people who pulled up next to it in their automobile or wagon.

THE LORD AMHERST MOTOR HOTEL. Amherst builder Willard H. Genrich erected the Lord Amherst Motor Hotel on Main Street near the interchange of the New York State Thruway (Interstate 90) and the Youngmann Memorial Highway (Interstate 290). Located just outside the western boundary of the village of Williamsville, it was designed to harmonize architecturally with the Colonial motif used by the businesses along Main Street in the village. A fine restaurant was included among its facilities.

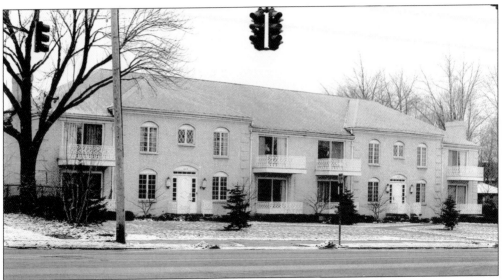

MULTIPLE DWELLINGS. Suburban development brought the rise of multiple dwellings. Some rose near the University of Buffalo, now the South Campus of the State University of New York at Buffalo, in the Main Street-Kenmore Avenue area. Others were erected farther up Main Street, like these at Main Street and Amherstdale Road, which were constructed on land near the site where Timothy S. Hopkins built his new bride a home at the beginning of the 19th century.

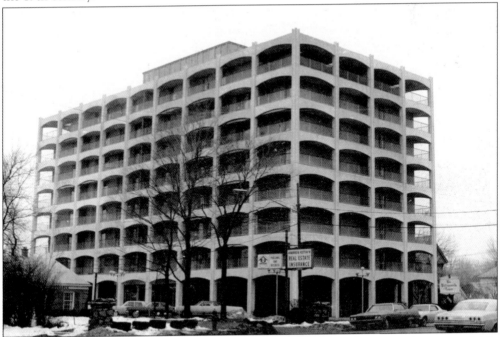

THE WILLIAMSVILLE TOWER. In 1969, some 35 percent of the new housing units were multiple dwellings; by the 1970s, that figure had risen to 68 percent. A major controversy broke out when proposals were made to build high-rise apartment buildings in Williamsville. The construction of the Williamsville Towers at Main and Rinewalt Streets occasioned loud protest against destroying the village character of the community.

101

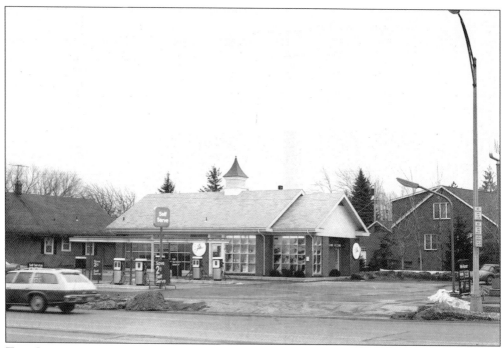

THE GAS STATION CONTROVERSY. With the coming of the automobile, more and more gas stations dotted the landscape in Williamsville and around the town. Controversies surrounded them in various ways. The appearance of self-service gas pumps was opposed by those who felt customers would be careless by smoking while pumping gas. One very heated battle broke out when the Mobile Oil Company got permission to build a station (pictured) at the corner of Main Street and Garrison Road, where many children crossed Main Street to attend the Academy Street School. Mothers' pickets and petitions failed to prevent the station's construction. Ironically, it has recently been demolished.

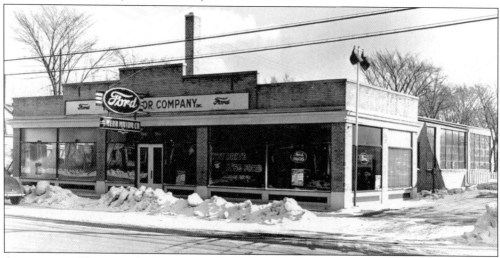

AUTOMOBILE DEALERS. Many automobile sales agencies like the Read Ford Motor agency opened their doors along Main Street in Williamsville. The Read agency rose on the original site of the Evans homestead, built in the 1790s. These agencies eventually moved out to Transit Road because they needed more space to run their businesses.

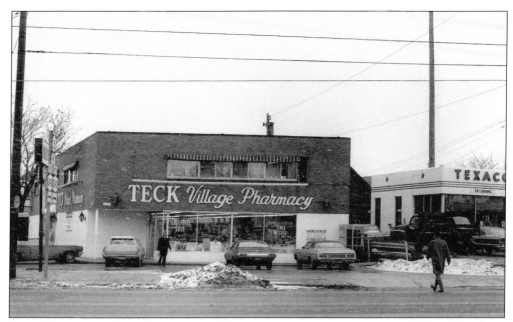

TECK PHARMACY. Teck Pharmacy stood for many years at the corner of Main Street and Harlem Road near the site of the Snyder home. The gas station next-door reflected the growing transformation of this area of Amherst.

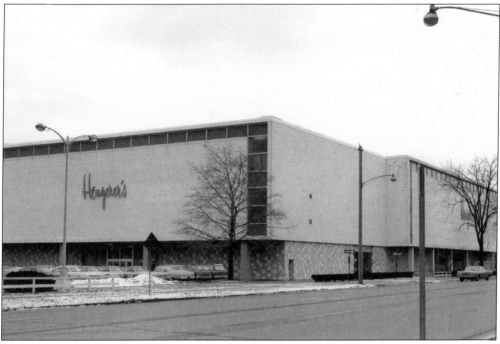

HENGERER'S DEPARTMENT STORE. Major Buffalo department stores opened suburban branches. In 1958, the William T. Hengerer Company, with its roots dating back to the Erie Canal trade, bought the Manning Dairy land at the corner of Eggert Road and Main Street and built an impressive branch store.

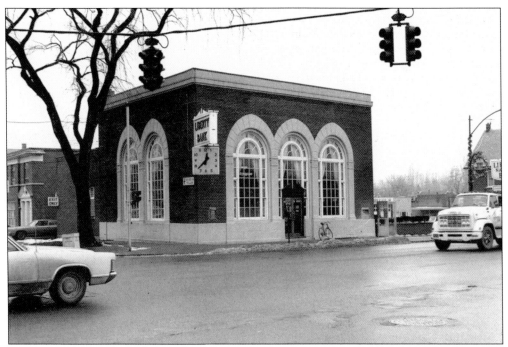

LIBERTY BANK. Although Amherst had established its own banks, many were taken over by larger Buffalo institutions. Liberty Bank, known as the German-American Bank until World War I, opened a branch at Main Street and Cayuga Road in Williamsville.

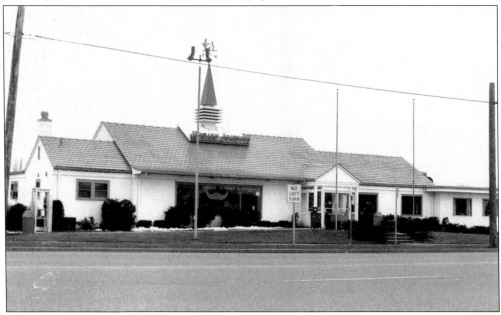

HOWARD JOHNSON'S. As suburbanization continued in Amherst, national business chains opened branches in the town. One such chain was Howard Johnson's, which opened a Colonial-style eatery at Main Street and Kensington Avenue, reflecting its New England origins and matching the Colonial theme of the nearby Lord Amherst Motor Hotel and of many businesses along Main Street.

THE BRITTING INSURANCE AGENCY.
Local businesses also remained on Main
Street. Among them was the insurance
agency of Howard Britting, who had a
long career in real estate, banking, and
politics. Britting served as town supervisor
from 1934 to 1941 and thereafter helped
found the Williamsville Historical Society
and served as the town's first official
historian.

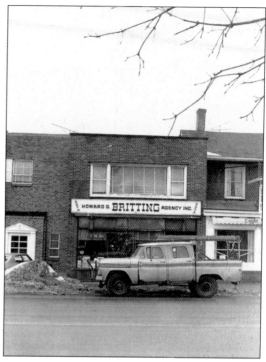

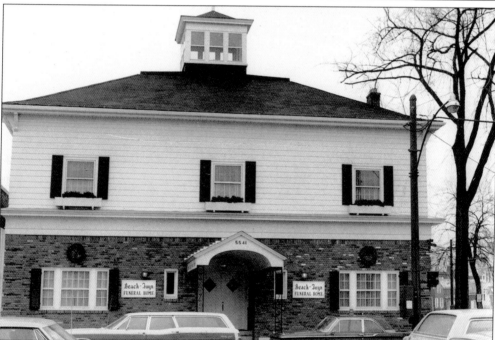

THE BEACH-TUYN FUNERAL HOME. The Beach-Tuyn Funeral Home is one of Amherst's
landmarks. Located on the site of what was Demeter Wehrle's furniture and coffin business,
the present building was built in the late 19th century at the corner of Main Street and Cayuga
Road and remodeled to look like it does today. The business still involves members of the
family of Demeter Wehrle, who, in addition to making coffins, was the village undertaker.

THE LITTLE WHITE HOUSE. On Main Street in eastern Williamsville, what is still referred to as the Little White House traces its origin to a food concession at the Williamsville Driving Park racetrack. Later, the Williamsville Drive Park Hotel was built with a restaurant to serve racetrack patrons. Even when the track closed in 1908, the restaurant continued under various proprietors. In 1960, it underwent a major renovation that used its historic background as the motif. A very popular eating place, it now specializes in Italian cuisine.

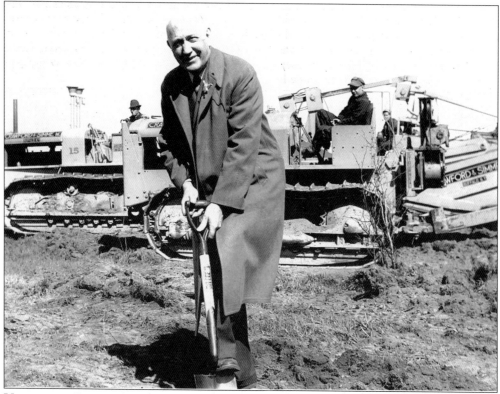

UNIVERSITY PLAZA. Shown is Amherst Supervisor Howard Britting breaking ground on May 10, 1941, for western New York's pioneer shopping center, University Plaza. Located on the southwest corner of the town near the original University of Buffalo campus, now the South Campus of State University of New York at Buffalo, it was one of the nation's first plazas. It contained 18 stores including major national chains like W. T. Grant and A & P, as well as a movie house. Ample parking was provided both in front and in back of the plaza.

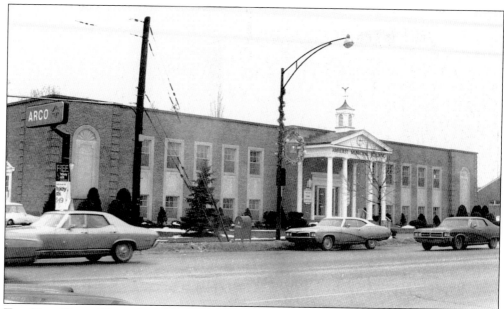

THE NEW TOWN HALL. In 1965, the old gray stone village hall was demolished to make way for a new government center to serve the needs of a rapidly growing community. Erected on the site of the old government center was a new Colonial-style town hall, with room to house the necessary government agencies. A separate village hall now stands a short distance away, as does the home of the Hutchinson Hose Fire Company.

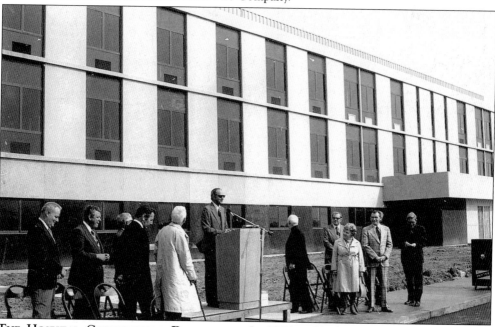

THE HOSPITAL CORNERSTONE DEDICATION. In 1974, a 20-plus-year campaign to build a hospital to serve the growing population of the Northtowns came to fruition with the opening of Millard Fillmore Suburban Hospital on Maple Road between Hopkins and Youngs Roads. Ground was broken for the 110-bed hospital in February 1972, and the cornerstone dedication, took place in October 1973.

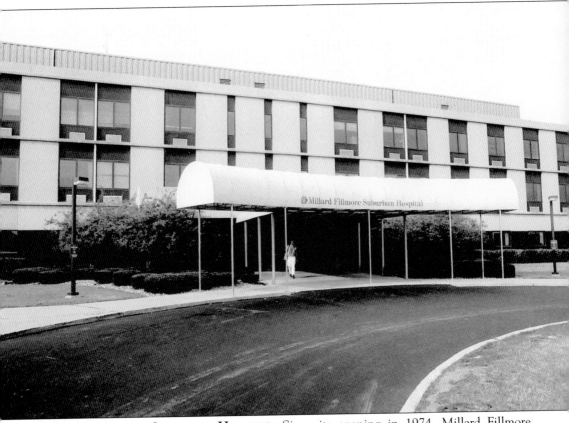

MILLARD FILLMORE SUBURBAN HOSPITAL. Since its opening in 1974, Millard Fillmore Suburban Hospital has been expanded to meet the needs of an ever-growing community. It now is undergoing another multimillion dollar expansion. Tied to Buffalo's Millard Fillmore Hospital at Gates Circle, a teaching hospital, it is now part of the Kaleida Heath System, which includes four other hospitals, as well as many health-related facilities.

Seven

AMHERST TODAY

The Amherst of today is a far cry from the rural 19th-century town with its many hamlets. It has become a major economic hub in western New York, with malls, corporate parks, industrial parks, and business headquarters. It also is an educational hub that includes the main campus of the State University of New York at Buffalo, with its 1,000-plus acres and 20,000 students. Complementing this are several smaller institutions of higher education. With a population of 115,000, Amherst has amenities that attract people who choose to make it their home. There are first-rate school systems, an outstanding recreational program, and unique cultural institutions such as the Amherst Museum, with its historic 19th-century village of restored buildings. It is a town with a population rich in diversity of ethnic backgrounds and religions that are celebrated by an international festival called Amherst Together. It contains numerous medical and medical-related facilities, as well as a host of different types of senior citizen facilities ranging from apartments to full nursing home care. In short, it is a vibrant community of which its citizens can be proud.

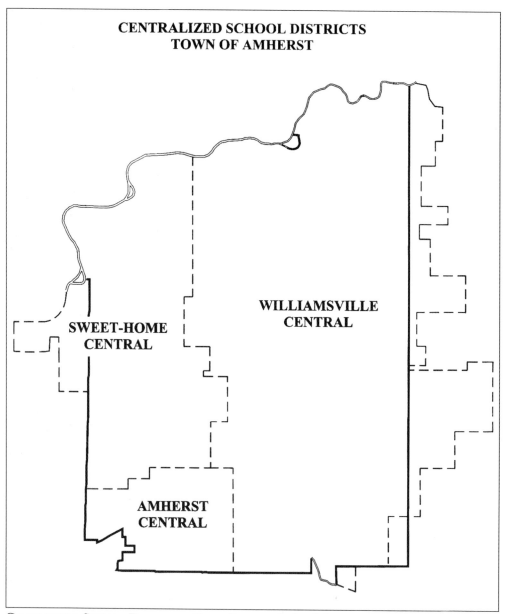

CENTRALIZED SCHOOL DISTRICTS
TOWN OF AMHERST

WILLIAMSVILLE
CENTRAL

SWEET-HOME
CENTRAL

AMHERST
CENTRAL

Centralized School Districts. Centralization of school districts in Amherst created three districts, parts of which spilled over into nearby towns. Thus, the Williamsville School District includes parts of the western town of Clarence, and the Sweet Home School District includes parts of the eastern town of Tonawanda.

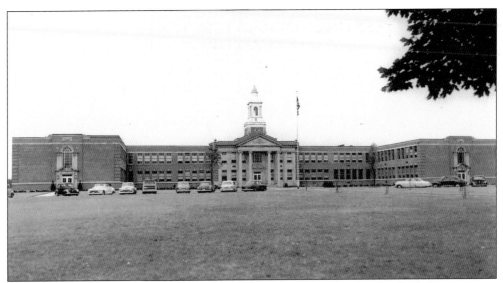

WILLIAMSVILLE SOUTH HIGH SCHOOL. There are five public high schools and two private ones in Amherst, along with many elementary schools. Shown is the first modern high school built in the Williamsville School District, the largest of the three districts in the town. Opened in 1950, Williamsville South High School is one of three high schools in the district, along with Williamsville North and Williamsville East. Other public high schools are Amherst High School and Sweet Home High School. The private high schools are the Park School and Sacred Heart Academy.

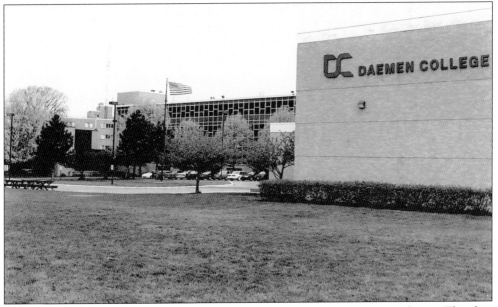

DAEMEN COLLEGE. Higher education is now a major enterprise in Amherst. The first institution of higher education to locate here was Daemen College, on Main Street in Snyder, now a coeducational, independent, nondenominational college. It was founded in 1948 as Rosary Hill College, a women's liberal arts institution under the auspices of the Sisters of St. Francis of Penance and Charity. Its 30-plus-acre campus was once the site of several Amherst estates.

THE NORTH CAMPUS. The construction of a new State University of New York at Buffalo campus on 1,000-plus acres of land in Amherst has had a profound effect on the town character in areas such as population diversity and business enterprise. Begun in 1970 and housing over 20,000 students, it is part of a two-campus institution that includes the old University of Buffalo campus on Main Street and Bailey Avenue on the Buffalo-Amherst border. The Commons (left) is a North Campus retail mall with an imposing clock tower. Students at the North Campus Performing Arts Center (below) look across Lake LaSalle at the Ellicott Complex, a major campus residential center.

ERIE COMMUNITY COLLEGE. In the 1960s, Erie County purchased 120 acres on Youngs Road between Main Street and Wehrle Drive. Here was built a new campus for the then Erie County Technical Institute, a school meant to serve the needs of the business community and attract new businesses as well. Later renamed Erie Community College – North Campus, it is now part of a three-campus institution with a much broader curriculum.

AUDUBON PUBLIC LIBRARY. The importance of learning is reflected in Amherst by a four-unit library system headquartered at Audubon Public Library, on John James Audubon Parkway. It leads all Erie County libraries in circulation with another Amherst unit, the Clearfield Branch Library not far behind.

BOULEVARD MALL. Amherst is now a major economic hub in western New York and includes an array of plazas along its major thoroughfares. Among them is Boulevard Mall, at Niagara Falls Boulevard and Maple Road, dating back to the 1960s. It was one of the first enclosed malls in the United States and is still undergoing expansion.

AUDUBON INDUSTRIAL PARK. Industrial and business parks are now common sites in Amherst. Audubon Industrial Park has a 48-acre site near the state university and was designed for commercial and light industrial enterprises.

TOPS AND NATIONAL FUEL OFFICES. This Main Street building in eastern Amherst houses the regional headquarters of the largest supermarket chain in western New York, Tops Friendly Markets, as well as the general headquarters of the National Fuel Gas Corporation, which serves western New York and Pennsylvania.

THE UNILAND OFFICE COMPLEX. Uniland Development Company, a major developer in the area, built a five-building office park on Maple Road east of Sweet Home Road. Its corporate headquarters are located here, as are other business ventures and a satellite campus of Canisius College that focuses on business programs.

OPERATING FARMS. Now a business center, the once heavily agricultural Amherst contains very few farms still in operation, mostly in the northern and eastern parts of the town. One existing farm is Ben Brook Farm (above), run by the Vilonen family. Located on Tonawanda Creek Road, it specializes in raising flowers. Another, on the same road, is Spoth Farm. Badding Brothers (below), on Transit Road, recently expanded its market to accommodate increased business in fruits, vegetables, and flowers.

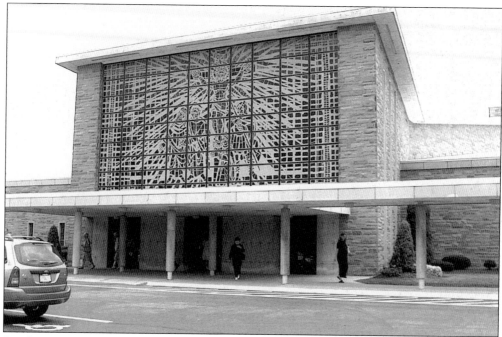

ST. GREGORY THE GREAT. Religion has been an important part of the lives of many Amherst citizens from the very beginning. Catholics migrated to Amherst very early. One of the newest Catholic parishes, St. Gregory the Great, on Maple Road, was founded in 1958 and has become a veritable "megachurch," with over 5,000 families.

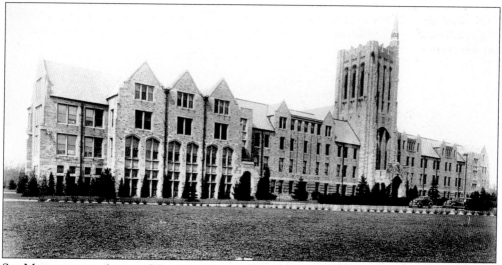

ST. MARY OF THE ANGELS MOTHER HOUSE. The Sisters of St. Francis of the Third Order of Buffalo built a grand mother house on Mill Street land given to them by John Blocher. Erected in 1926, it was an impressive four-story stone Gothic Revival structure. It served as a place of study for women planning to enter the order, as well as a school, a home for the elderly, and a residence for retired sisters. When the sisters built a new mother house on Reist Street, they sold the original building and a large tract of surrounding land to the town of Amherst. The building was privately converted into apartments for the elderly, and the surrounding land was designated as Amherst State Park, to be enjoyed by all citizens.

THE CHAPEL. The largest Protestant congregation in Amherst is the Chapel, on North Forest Road. Founded by a minister raised in Amherst, the Reverend James W. Andrews, the congregation numbers 4,000 and will soon build a new and larger house of worship in the northern part of the town.

TEMPLE BETH AM. Jews were among the population movement from Buffalo to the suburbs. A group of young Jewish couples in 1955 formed a new congregation, Temple Beth Am, which by 1960, had its own house of worship (shown) on Sheridan Drive and Indian Trail. Other Jewish houses of worship and schools followed. Also established was a Jewish center meant to serve all members of the Jewish community with educational, recreational, and social work programs.

RELIGIOUS AND CULTURAL CENTERS. Religious diversity in Amherst is emphasized by the Hindu Cultural Center (above), on North French Road, and the Islamic Society Center (below), on Heim Road, which serve their members with a variety of programs.

THE ELLICOTT CREEK TRAILWAY. Amherst has an ambitious recreational program for people of all ages. The Ellicott Creek Trailway extends for miles along the creek through the town for the enjoyment of walkers, joggers, bikers, and rollerbladers.

THE AUDUBON GOLF COURSE. Nearby is the 267-acre, 18-hole Audubon Golf Course, purchased by the town in 1961. Also available are the Par Three Course, across Maple Road from the Audubon course, and the 9-hole Oakwood Golf Course, on Tonawanda Creek Road.

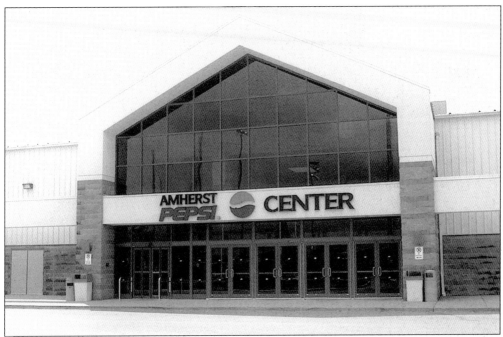

THE AMHERST PEPSI CENTER. The Amherst Pepsi Center is a major recreational facility, located near Maple Road and Millersport Highway. It is used by the professional Buffalo Sabers hockey team as a practice facility. Among its many programs are the Steal the Show youth hockey clinic (below), a beginner's hockey clinic for children, skating lessons by the Amherst Skating Club, and various events sponsored by the Amherst Youth Board.

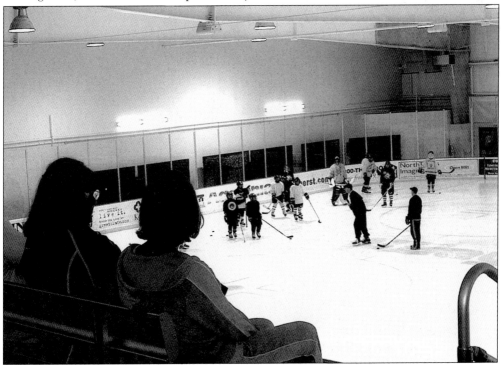

THE SENIOR CENTER. Facilities for seniors abound in Amherst. A senior citizen center tracing its origins to the early 1960s is now housed in a new facility on John James Audubon Parkway (above). Thousands of seniors participate in its programs, among them Josephine Campagna, Fran Peterson, and Viv Parker (below), getting ready for a flea market at the center.

AMBERLEIGH. Among the senior residences in Amherst is Amberleigh, a housing complex on Maple Road near Transit Road. It is home to the well-aged and provides transportation for shopping, church attendance, and other necessities.

WEINBERG CAMPUS. Weinberg Campus, on North Forest Road, is a comprehensive senior facility. It features retirement apartments, assisted living facilities, and nursing home care, as well as home and day care. It was established by the board of directors of Buffalo's Rosa Coplon Living Center (named after a pioneer in the home nursing field) to provide needed room for expanding services.

OLD HOME DAYS. Old Home Days is the biggest community-wide civic celebration in the village of Williamsville and the town of Amherst. Held annually in July, the event attracts thousands of children and adults. It begins with a long parade in which diverse community organizations are represented, and it continues with several carnival days in Island Park, behind the town hall. Organizations have information booths or run game booths or food booths to raise money for their activities. A stage is set up for performances by music and dance groups. A special day is set aside to entertain handicapped children. Above is a picture of the main concourse with booths on both sides and a major food and drink shelter at the end. Below is a member of Amherst Youth Engaged in Services, one of the town's many youth groups, doing face painting on a young visitor at the fair.

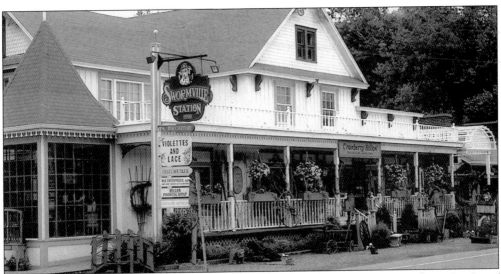

SWORMVILLE STATION. The hamlet of Swormville, along Transit Road on the east border of Amherst, is partly located in the town of Clarence. The people of Swormville have a strong sense of their history. One of the major buildings at Smith Road and Transit Roads was converted into Swormville Station, which contains a number of specialty shops selling a variety of unique items. It adds a historic flavor to the hamlet of today.

THE AMHERST BEE. Much of the town's history is preserved among the pages of the *Amherst Bee*, which has been published since 1879. The paper is a rich repository of material about the people and events which took place in Amherst over the last 125 years. Editorials, news columns, and advertisements reflect the flavor of years past. Additionally, there are articles on the town's history, especially a series by the late town historian Sue Miller Young. Located on Main Street in the village of Williamsville across from the government buildings, the *Amherst Bee* is now part of the Bee Group, a network of nine community papers published in suburban Buffalo towns.

THE MEASER FAMILY. The *Amherst Bee* has been in the hands of the Measer family since 1907. In that year, founder Adam L. Rinewalt sold the newspaper to George J. Measer Sr., who had been employed there for six years. Measer operated the newspaper until his death in 1965, when his son, George J. Measer Jr. (center) took over. During the son's tenure, the Bee Group grew. Upon his retirement in 1994, his son Trey Measer (second from the left) stepped in. Pictured are three generations of the Measer family. Along with the father and son are Michael Measer (left), Melissa Measer, and Robert Measer.

THE AMHERST MUSEUM. The Amherst Museum is the major conservator of the history of the town of Amherst. It is located on a 35-acre site at the juncture of New and Tonawanda Creek Roads in northern Amherst. Across the street from it is the Erie Canal, where a dock is planned to be used by boaters wishing to visit the Amherst Museum. The Shaw Building (pictured) is named in honor of the first museum director, Dr. Andrea Shaw. It is the main office and exhibit facility of the museum.

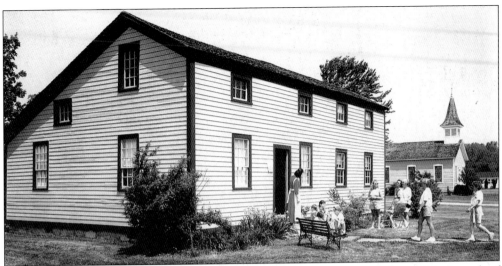

THE BIGELOW HOUSE. The Amherst Museum's 35-acre property includes a historic park of 19th-century buildings that were moved here from different parts of the town and restored. Among the 13 buildings are the original Trinity Evangelical Lutheran Church (right), built c. 1854 on Transit Road; several schools; a unique Swormville barbershop that also served as a photographer's studio; a blacksmith shop; and a number of 19th-century homes, including the Bigelow House, a saltbox structure built in the mid-19th century at New and Smith Roads.

THE AMHERST MUSEUM SCOTTISH FESTIVAL. The Amherst Museum holds a full program of events during the course of the year, including a quilt show, a lace show, art exhibits, tours for schoolchildren, and various exhibits prepared at the museum or brought in from outside. Among the 20-plus events are the annual Scottish Festival and Highland Games, which attracts over 4,000 people each year and offers Scottish games, bagpipers, dancers, and food; Amherst Together, which celebrates the diversity of cultures in Amherst and western New York; and the Harvest Festival and Craft Show, which focuses on the agricultural history of Amherst with produce, food, crafts, and farmers.

AMHERST MEMORIAL HILL GROVE AND MEMORIAL BENCH. Amherst Memorial Hill Grove, located along the Ellicott Creek Trailway, is dedicated to the memory of those who died in the September 11, 2001, tragedy. A grove of some 100 trees surrounds the flagpole and stone monument of the memorial. At the base of each tree is a plaque mounted on stone that indicates to whom the tree is dedicated and the name of the person(s) or organization sponsoring the memorial tree. Remembered especially are those with Amherst connections. The memorial bench (below) is dedicated to Leonard M. Castrianno, an Amherst native and graduate of Williamsville East High School. A student at New York University completing a degree in electrical engineering, the 30-year-old managed a trading desk for Cantor Fitzgerald on the 105th floor of the North Tower of the World Trade Center.